the watercolor
artist's
paper directory

DISCOVER THE BEST PAPER FOR YOUR ART!

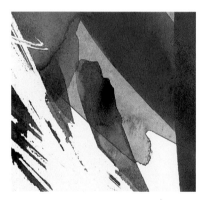
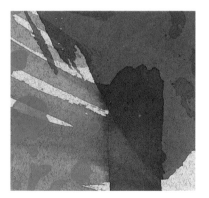

Covers in detail the qualities of 30 different
watercolor papers and their creative uses

IAN SIDAWAY

**NORTH
LIGHT
BOOKS**

Cincinnati, Ohio

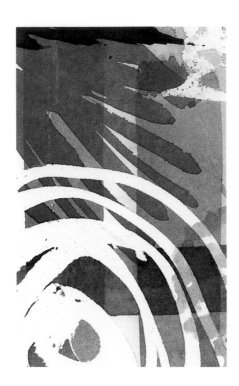

A QUARTO BOOK

First published in North America
in 2000 by North Light Books,
an imprint of F&W Publications, Inc.
1507 Dana Avenue, Cincinnati, OH 45207
1-800/289-0963

ISBN 1-58180-034-7

QUAR.BPT

Conceived, designed and produced by
Quarto Publishing plc
The Old Brewery
6 Blundell Street
London N7 9BH

Editor Steffanie Diamond Brown
Senior Art Editor Penny Cobb
Copy Editor Ian Kearey
Designer Karin Skånberg
Photographer Paul Forester
Indexer Dawn Butcher
Picture Research Laurent Boubounelle, Frank Crawford

Art Director Moira Clinch
Publisher Piers Spence

Manufactured by Regent Publishing Services Ltd, Hong Kong.
Printed by Leefung-Asco Printers, China.

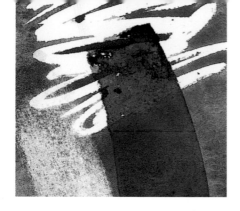

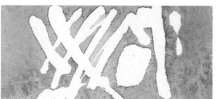

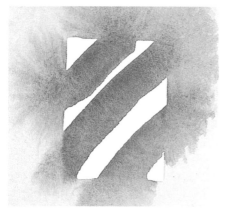

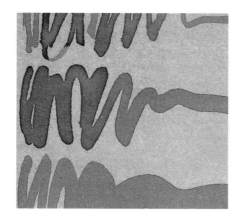

contents

Introduction

Watercolor is unique among the mediums—both wet and dry—enjoyed by visual artists. Its characteristics present the artist with a particular set of challenges, all of which are interrelated. Their solution lies in technique, expertise, and planning; it also depends to a large extent on the quality of the paper being used.

Inner light

Pure watercolor is a transparent medium in which thin washes of color are glazed one on top of the other. Colors are lightened, not with white paint, but by the addition of water. This thins the color, allowing more light to reflect back from the white support through the wash, and making it appear lighter. Achieving the resultant glow, or inner light, that epitomizes the very best watercolors, is the goal of all watercolor artists.

Unpredictability

Watercolor often seems to have a will of its own. This is because the water and the pigment continue to move until the paint is thoroughly dry. Colors blend, bleed, and separate into one another; they soak, settle, and dry into the paper in sometimes spectacular ways long after the artist has painted them. This is the attribute that gives watercolor its reputation for unpredictability.

No margin for error

Corrections are not impossible, but the actions of the paint, coupled with a sometimes delicate paper, make them undesirable and often difficult. This obliges the artist to plan ahead in an attempt to get it right first time.

The right paper

The choice of paper will have a profound effect on all of these characteristics, and on the techniques that are crucial to the artist's repertoire. Producing work that meets one's expectations can be difficult enough without struggling to work on a paper that is unsympathetic to one's needs.

This book examines objectively the characteristics of many of the watercolor papers available. Its aim is not to suggest that one paper is better than another, but to help you find the paper or papers that are best for your needs. There are, of course, hundreds of papers of various weights, surface textures, and shades of white manufactured worldwide, and we can only show you some of them. If, having read this book, you come across an unfamiliar paper that looks interesting, buy a sheet and try it—you might be in for a satisfying surprise.

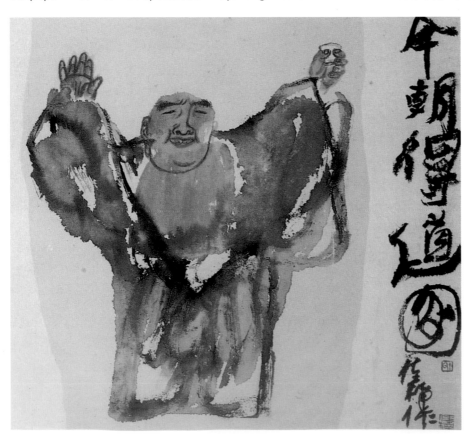

Wang Jia Nan and Cai Xiaoli
The Jolly Monk
Grass paper

The absorbent characteristics of this paper are cleverly exploited here by using a combination of thin, loose washes. These washes were allowed to spread relatively freely and to dry thoroughly before the image was strengthened and brought into focus with brushed-on line work.

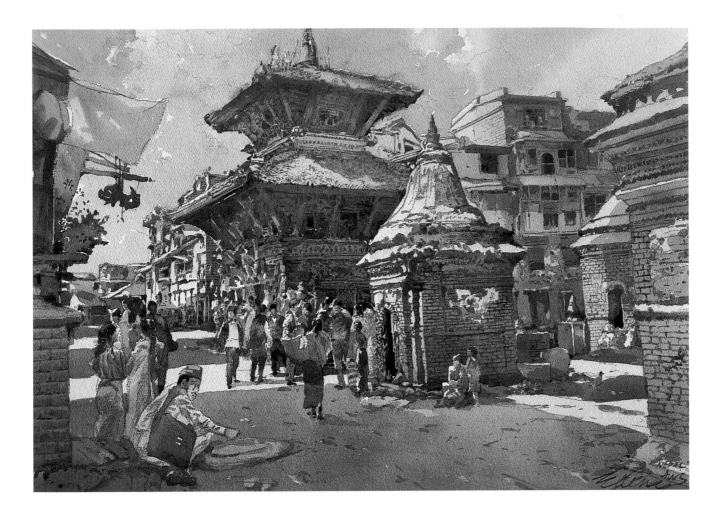

Ong Kim Seng
Thimi, Nepal
Rough surface paper

This painting was done on
300 lb (600gsm) Arches paper.
The paper was not stretched,
as it is a heavyweight paper.
The painting utilizes a limited
range of colors, which adeptly
capture the light by using
strong contrasts of light and
shade and interesting tonal
combinations.

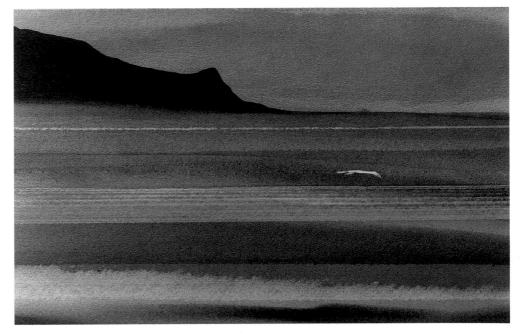

R. Tilling Landscape
Cold-pressed paper

The smooth surface of this paper helps the
wet-in-wet and wet-on-dry washes maintain their
fluidity and the appearance of wetness when dry.
Clever use of masking, using torn paper, helps to
separate the transition of one color into another.

Manufacturing paper

The making of paper has scarcely changed in almost 2000 years. Although methods have been refined, a Chinese papermaker living in the 1st century AD would easily understand what was happening in a paper mill today.

The substance of paper

Paper is made from the cellulose fibers found in plant material. A variety of plants are used (including jute, hemp, and wood pulp), but by far the best cellulose comes from a member of the mallow family, *Gossypium herbaceum*, or cotton. A remarkable plant, cotton is high in cellulose, and its fibers are easily extracted.

The cotton fiber used in papermaking comes from two sources: cotton rags and cotton linters. Cotton rags consist of the long threads found in woven fabric. Cotton linters are soft sheets, resembling blotting paper, that are made from the short cotton fibers not used in the spinning of thread.

Handmade paper

Making paper by hand involves two distinct stages. First, the vegetable fibers are washed clean, separated by crushing and beating, and suspended in water. The thick soup of cleaned and pulped cellulose fiber suspended in water is known as "half stuff." In the second stage, the mesh surface of a mold is coated with a thin film of pulp. This is achieved by dipping the mold into the vat of pulp, lifting the now coated mesh clear, and shaking it to align and interlock the fibers in all directions. The surplus water is allowed to drain away, and the sheet of paper is turned out onto a damp felt blanket known as a couching felt.

Once a pile, or post, of paper and felts has been formed, they are pressed to remove more water. The paper is then separated from the felts and allowed to dry.

The mold used to form the sheet consists of a fine wire mesh held by a wooden frame. A mesh with an even crisscross pattern imparts a "wove" finish to the paper surface; a mesh composed of fine parallel wires gives the paper a "laid" surface. A second frame, known as a deckle, sits over the first to prevent the pulp from running off the edge of the mold. The deckle, which gives some papers their distinctive edges, is removed before the sheet of paper is turned out onto the couching felt.

Machine-made paper

During mechanical production, a continuous sheet of paper is formed on a cylinder-mold machine, which consists of a continuous wire-mesh belt onto which the pulp is spread. Rubber deckles prevent the pulp from falling off the belt while the water drains through the mesh. The pulp-covered belt passes between felt-covered couching rolls that press out more water and consolidate the paper fibers. Once separated from the mesh belt, the paper is passed through a series of heated rollers that dry and finish the surface before the paper is cut into sheets. Cylinder-mold papers have two deckle edges and two cut edges, although two extra deckles are sometimes simulated to give a handmade appearance. Some cylinder-mold papers have four cut edges due to the width of the machine belt.

Most manufactured paper is produced on a Fourdrinier machine, which speeds the cylinder-mold method, so that the sheet of pulp is drained and dried thoroughly before being felted.

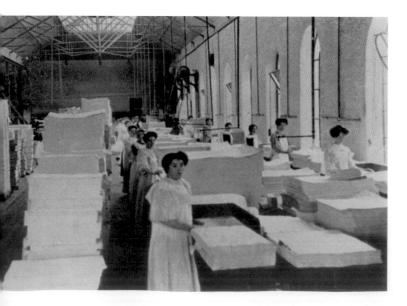

Old-fashioned papermaking This photograph, taken c. 1924, shows the overhauling room at St. Cuthberts Mill in Somerset, England. The workers can be seen checking and stacking individual sheets of paper. The sheets were placed in two-sided boxes, to facilitate neat stacking.

Processing watercolor paper

Watercolor papers are made using a square-pattern mold mesh, which produces a wove surface. The paper is then processed to create one of three distinct surface textures: Rough, Cold-pressed, or Hot-pressed.

Cold-pressed

The surface of a Cold-pressed sheet has a slight texture. In handmade paper, this results from re-pressing the newly formed wet sheet without intermediate couching felts, which smooths the rough surface somewhat, but not completely. A similar effect is achieved mechanically by running the wet sheets between cold metal rollers. Cold-pressed papers are generally considered the easiest to use. The surface is receptive, with enough texture to make both broad and fine work possible.

Rough

This paper has a rough texture, as the name suggests. This texture is achieved by allowing the couching felts to imprint their pattern on the sheet, which is then left to dry without additional pressing. In the case of handmade paper, pressing between felts is omitted, so that the natural surface of the sheet is retained. Certain Rough papers are very rough indeed, and are not for the fainthearted. A Rough surface paper responds best to a bold and immediate style.

Hot-pressed

The surface of Hot-pressed paper is made very smooth by passing the freshly formed sheet through hot metal rollers, or plates. This action irons out any texture left by the felts, producing a hard, featureless surface, upon which watercolor washes can be difficult to control.

Absorbency and sizing

Paper that is left unsized—blotting paper, for example—is known as waterleaf, and cannot be used for watercolor. Sizing a paper makes it less absorbent, more water-resistant, and better able to hold a watercolor wash or brushmark. Various natural and synthetic sizes are used in papermaking, including gelatin, casein, starch, and rosin made from the pine-tree resin.

Size can be added to the pulp before the sheet is formed, or to the surface after the sheet has dried. Papers that are lightly sized absorb more paint, making corrections difficult. Washes have softer edges, and colors tend to dry slightly duller. Heavily sized papers soak up less paint, and the paint is more likely to dry on the surface of the paper, which enables rewetting and reworking. Paint can also be more easily removed by scratching. Colors tend to look more vibrant, and washes are more easily merged.

Atmospheric conditions can alter the behavior of watercolor paper. If the air is damp, the moisture held within the paper fibers can increase, affecting the way washes spread and settle.

Weight

A paper's weight describes the thickness of a single sheet of paper. The weight is expressed in pounds in the USA, and in grams in most other countries.

Figures in pounds (lb) define the weight of a ream (500 sheets) of paper of any given size. A sheet of fairly thick paper measuring 22 x 30 in could be described as a 300 lb paper. The same paper in a 40 x 60 in sheet would be described as a 1114 lb paper, because a ream of the larger paper would be heavier. The metric measurement expresses a sheet's weight in grams per square meter (gsm). The equivalent of a 22 x 30 in sheet of 300 lb paper is 640gsm; a 40 x 60 in sheet of the same paper is also 640gsm, because the two sheets are the same thickness.

Color and acidity

For pure watercolor work, the paper must be white. But comparing a few different sheets soon reveals that the color white can vary considerably. Various factors in the manufacturing process influence the whiteness of a paper, and some papermakers add an optical brightening agent to the pulp. While the choice of white is ultimately a matter of individual preference, many artists prefer to work on paper that is not too bright. A few papermakers, including Bockingford, Two Rivers, and Khadi, produce a line of color-tinted watercolor papers.

Another consideration is the paper's acidity, or pH level. High acidity contributes to the oxidation that causes paper to deteriorate and yellow. Factors that affect acidity range from the water used in the manufacturing process to improper storage and frequent handling. A pH level of 7 is considered neutral. While few papers measure exactly 7, most fall between 6.5 and 7.5 on the pH scale. In order to absorb any environmental or atmospheric acidity, some manufacturers add a buffering agent, such as magnesium or calcium carbonate, to the pulp.

Deckles and watermarks

Although aesthetically pleasing, deckles and watermarks have no direct influence on the quality of the paper. The deckle edge, which is found on all four sides of a handmade sheet and on the two opposite sides of many machine-made sheets (see p. 6), is formed by a thin layer of pulp creeping beneath the part of the mold known as the deckle. We now consider this a mark of quality, but it was once regarded as an imperfection and was cut away. A pronounced deckle edge can be a problem when stretching paper with the aid of adhesive paper tape. In this situation, the deckle is best removed. Watermarks are created by attaching a bent copper wire design to the flat mesh of the mold. When the layer of pulp is floated onto the mold, it forms more thinly over the raised design. This can be seen when

Whiteness Though invariably white, watercolor paper is available in a wide range of shades, from brilliant white to cream. The whiteness of the paper will have a direct effect on your color washes.

Embossing and deckled edges An embossed manufacturer's mark indicates which is the correct side of the paper to work upon. The number of deckles is a sign of how the paper was made. A handmade sheet of paper will have four deckle edges, while machine-made sheets typically have only two.

Watermarks These markings show the paper's manufacturer, and indicate which is the correct side of the paper upon which to work. Some watermarks—the Fabriano cross, for example—have been in use for hundreds of years.

the sheet is dry by holding it up to the light. The first watermark is believed to have occurred by accident at the Fabriano paper mill in Italy c. 1282. Some papers include embossed or brand marks (also known as chopmarks). Like watermarks, they help determine the right side of the paper upon which to paint.

Size and availability

Sheets of paper are sold in a wide range of sizes. The bulk of paper is 22 x 30 in (560 x 760mm), but most paper companies also produce larger and smaller sheets, as well as rolls. Many of the better-known brands are also sold in sketchbooks, blocks, and small tablets, and are ready for use on location. You may need to shop around for a particular paper, or ask your local art supply store to order it for you.

Buying paper in a block of 12 or 20 sheets can be expensive, especially if you discover that the paper is unsuitable for your needs. It is better to buy single sheets until you decide which papers you prefer. Many paper distributors and supply stores offer discounts on 10 sheets or more, and big reductions on packs of 100 or 125 sheets.

Stretching paper

As a sheet of paper dries and shrinks during the course of a painting, its surface will buckle. The solution is to stretch the paper before use.

The right and wrong side of the paper While watercolor papers are manufactured with a "right" side—upon which the painter is supposed to work—in mind, in reality most papers can be used on either side.

When a sheet of watercolor paper is wet, the fibers that form the paper soak up the water and swell, increasing the overall size of the sheet. As the sheet dries and shrinks, as it will during the course of a painting, the surface starts to buckle, making additional flat washes of paint impossible. The liquid paint also tends to puddle in the paper's "valleys," drying darker and more slowly, and leaving watermarks which may be unwanted. The solution is to stretch the paper over a board or frame before use, so that it dries flat and retains its original size and shape.

Heavyweight papers of 300 lb (640gsm) do not need stretching, since their inherent thickness keeps them flat; unstretched papers over 200 lb (425gsm) will suffer only minimal buckling. Weights below 200 lb (425gsm), however, are notoriously prone to buckling. As a general rule, such papers should be stretched.

Paradoxically, the lightweight papers that need stretching can be the most awkward to stretch evenly, while medium-weight papers present few problems. If you are stretching paper for the first time, you should begin by practicing with the medium weights.

During stretching, the paper can be secured with adhesive paper tape, or with staples. Adhesive paper tape makes it easy to cut the paper from the board once the painting is finished. Paper stretched with staples can tear or pull loose along one edge during drying.

The right and wrong side

Every sheet has a "right" side that is considered better to work on. Most papers can be used on either side, however, depending on personal preference.

To find the correct side of a sheet of watermarked paper, hold the paper up to the light. The side from which you can read the watermark correctly is the side intended for use. The same is true of papers with an embossed or trade mark; when you see the mark the correct way around, you are looking at the right side of the sheet.

If the paper carries no marks, compare the two sides in good light. One side will usually show a more regular pattern, transferred to the paper from the wire mesh of the mold—this is the correct side upon which to work. The other side will have no such discernible pattern.

You will need:

- A sheet of watercolor paper
- A wooden board thick enough not to bend or warp, approximately 1 in (25mm) larger than your paper
- A roll of 2 in (50mm) adhesive paper tape
- Scissors
- A clean, soft, natural sponge
- Clean water

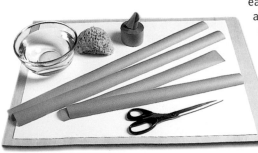

■ **1** To help you work quickly, prepare four strips of adhesive paper tape. Cut each strip approximately 2 in (50mm) longer than the side of the paper to which it will stick.

■ **2** Place the sheet centrally on the wooden board, right side up, and wet thoroughly with water squeezed from the sponge. Remove any excess water by gently sponging, taking care not to disturb the paper's surface.

■ **3** Alternatively, dip the paper into a water-filled tray, or hold it under the cold faucet in a sink or bathtub. Transfer the paper quickly to the stretching board, and gently sponge away any excess water, as before.

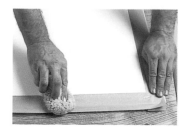

4 The degree of wetness depends on the weight and type of paper. Lightweight papers need only be damp, while heavier papers must be much wetter.

5 Medium- and heavyweight papers will lie flat, but lighter weight papers will begin to curl along their length almost immediately, so you will need to work as quickly as you can.

6 Wet one adhesive strip with the sponge, and apply it to one edge of the sheet, overlapping at each end by about 1 in (25mm). Smooth it with the sponge. Where it overlaps the board, smooth it over the edge. Do the same with the other edges. Apply the tape to any side.

7 The lateral pull from stretched paper can be considerable, and can drag the adhesive strip away from the board. Fastening the tape both down the board's edge and on its surface helps alleviate the problem. Or, pin each corner of the paper with a thumbtack.

▶ Using staples

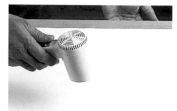

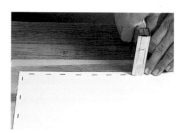

8 At this stage, the paper probably won't look flat, but don't panic. Set the paper-covered board aside and allow it to dry in its own time. One hour or so will be sufficient. Results are the same whether the board dries horizontally or propped vertically.

9 You can use a hairdryer to speed drying, but keep the dryer moving so that the paper dries evenly, and do not hold it too close to the paper surface. If the adhesive strip gets too hot, it will release its grip on the board, and you will have to begin again.

10 Instead of using paper tape, you can secure the paper with staples. You will need the same equipment, but a staple gun will replace the adhesive tape. Use ¼ in (6.25mm) staples. As before, wet the paper, position it on the board, and remove all excess water.

11 Working around the paper, position each staple about ¼ in (6.25mm) in from the edge. The spacing of the staples will depend upon the weight and strength of the paper. Thinner papers will need more staples to make them secure. Work quickly to insert all of the staples before the paper buckles.

▶ What went wrong?

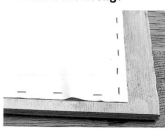

▶ Removing the paper

12 This paper has buckled because the staples were inserted one after the other around the sheet, causing the damp and swollen fibers to bunch up in one corner. If the paper looks as though it is going to buckle, place the staples opposite one another to minimize its movement.

13 Here, the adhesive strip has not adhered to the paper, allowing it to dry and relax rather than stretch tight. Using a few staples to secure the slack edge and rewetting the paper might solve the problem.

14 This problem stems from not wetting the paper uniformly. Leaving some parts dry while others are wet causes the paper to contract and dry at varying rates across its surface.

15 When your work is complete, remove the paper by cutting the adhesive tape where it joins the paper to the board, using a sharp knife. Staples take a bit longer to remove, as each one must be pried free. Loosen each staple with an awl and extract it with a pair of needle-nose pliers.

How to use this book

The aim of this book is to help you choose the right watercolor papers for your needs by providing an objective assessment of over 60 different papers from manufacturers all over the world.

This painting shows a montage of techniques, including wet-in-wet, wet-on-dry, masking fluid, wax resist, spattering, sponging, and the application of rock salt.

This section contains general information about the specific paper, including where and how it is made, and its appearance.

Here, we see how each paper reacts to 3B and 3H pencils, and to a steel-nib dip pen. Also demonstrated is the feasibility of rewetting water-soluble ink.

▼ **Main swatch spread**

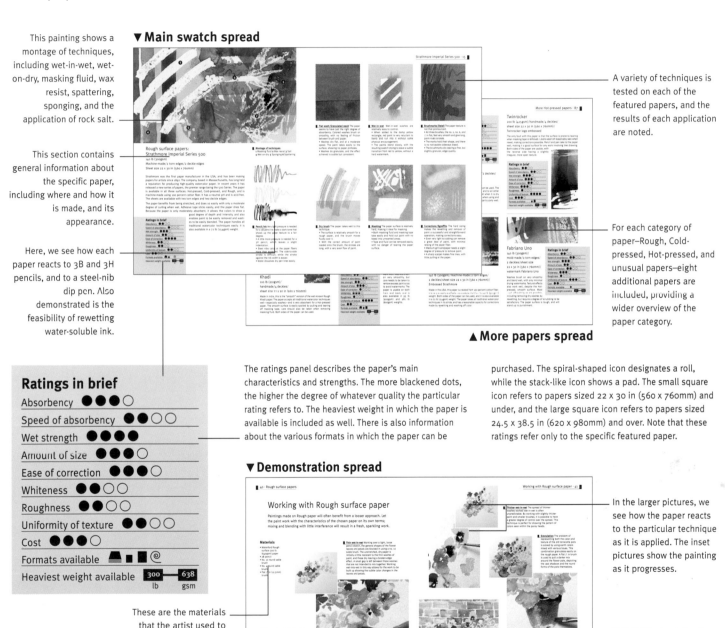

▲ **More papers spread**

A variety of techniques is tested on each of the featured papers, and the results of each application are noted.

For each category of paper—Rough, Cold-pressed, Hot-pressed, and unusual papers—eight additional papers are included, providing a wider overview of the paper category.

Ratings in brief

Absorbency	●●●○
Speed of absorbency	●●○○
Wet strength	●●●●
Amount of size	●●●○
Ease of correction	●●●○
Whiteness	●●○○
Roughness	●●○○
Uniformity of texture	●●○○
Cost	●●●○
Formats available	▬ ■ ▮ ◉
Heaviest weight available	300 lb — 638 gsm

The ratings panel describes the paper's main characteristics and strengths. The more blackened dots, the higher the degree of whatever quality the particular rating refers to. The heaviest weight in which the paper is available is included as well. There is also information about the various formats in which the paper can be purchased. The spiral-shaped icon designates a roll, while the stack-like icon shows a pad. The small square icon refers to papers sized 22 x 30 in (560 x 760mm) and under, and the large square icon refers to papers sized 24.5 x 38.5 in (620 x 980mm) and over. Note that these ratings refer only to the specific featured paper.

▼ **Demonstration spread**

These are the materials that the artist used to create the painting that is the subject of the demonstration.

In the larger pictures, we see how the paper reacts to the particular technique as it is applied. The inset pictures show the painting as it progresses.

This finished painting is the end result of the demonstration. Finishing techniques, where relevant, are detailed here as well.

Here, the texture of the paper that is the subject of the demonstration is described, both before and after the paint is applied. This caption also describes how the paper takes to the various painting techniques employed in the featured artwork.

rough surface papers

Characteristics:
Possesses a broken, uneven, craggy surface. Marked by irregularities, with pockmarks and indentations, the texture is grainy and bumpy, with many ridges and notches.

The degree of texture and tooth on Rough surface papers can range from the very rough to relatively smooth. They are usually available in heavier weights, and tend to be more absorbent than Cold-pressed or Hot-pressed papers. The characteristics inherent in the rougher papers call for a more direct, up-front approach, with confident brushwork. Washes usually lie very flat on the more absorbent papers, with fewer water- or drying marks. Colors tend to look bright, but they can become dull if too many washes are laid over one another.

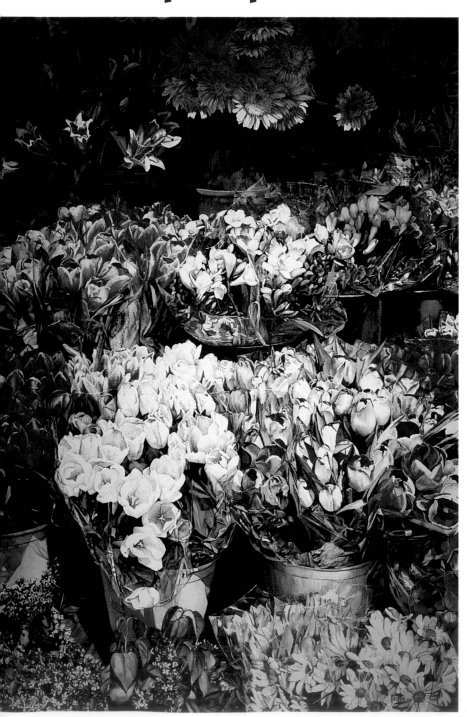

Mary Lou Ferbert Flower Market

This large, intricate watercolor uses the paper's characteristics to handle subtle wet-in-wet washes, which are then brought into sharper focus with stronger color washes, worked wet-on-dry. The white of the paper is utilized to great effect on the tulips.

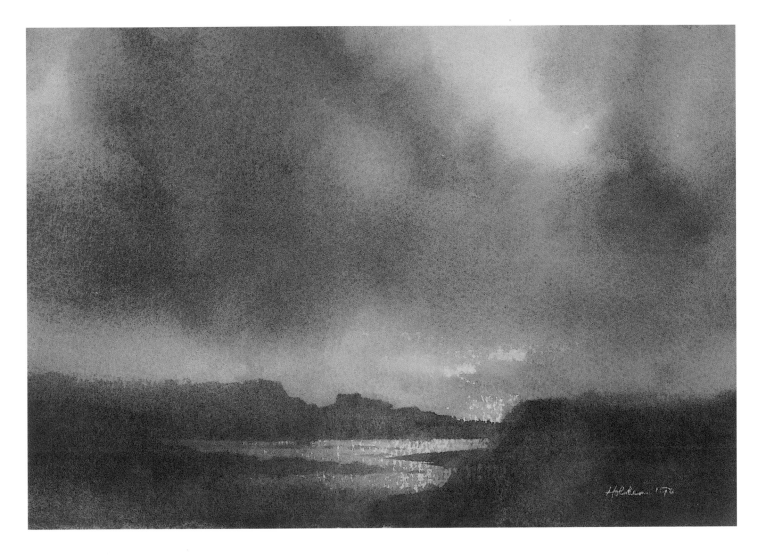

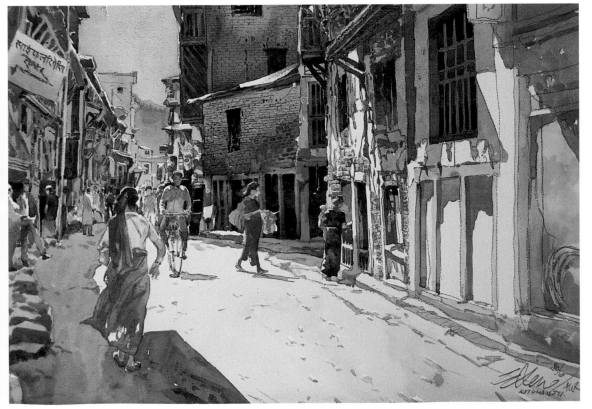

Donald Holden
Mendocino Storm

Painting on unstretched Arches paper, the artist has worked washes onto a very wet paper surface, then allowed them to bleed into one another as they are absorbed into the rough-textured paper.

Ong Kim Seng
Midday, Kathmandu

In this atmospheric painting, subtle transparent and semi-transparent glazes are built up layer upon layer to capture the intense light of midday.

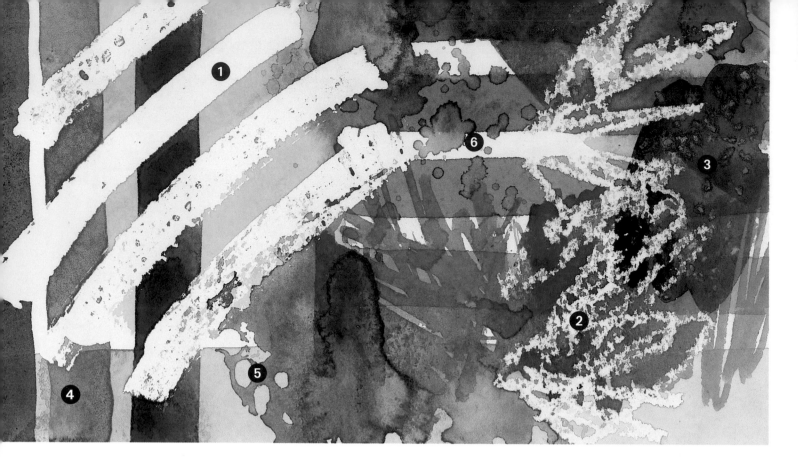

Rough surface papers:
Strathmore Imperial Series 500

140 lb (300gsm)

Machine-made/2 torn edges/2 deckle edges

Sheet size 22 x 30 in (560 x 760mm)

Strathmore was the first paper manufacturer in the USA, and has been making papers for artists since 1892. The company, based in Massachusetts, has long held a reputation for producing high-quality watercolor paper. In recent years it has released a new series of papers, the premier range being the 500 Series. The paper is available in all three surfaces: Hot-pressed, Cold-pressed, and Rough, and is machine-made using 100 percent cotton fiber. It has a neutral pH and is acid-free. The sheets are available with two torn edges and two deckle edges.

The paper benefits from being stretched, and does so easily with only a moderate degree of curling when wet. Adhesive tape sticks easily, and the paper dries flat. Because the paper is only moderately absorbent, it allows the colors to show a good degree of depth and intensity, and also enables paint to be easily removed and washes to be easily blended. The paper handles all traditional watercolor techniques easily. It is also available in a 72 lb (154gsm) weight.

Montage of techniques:
1 Masking fluid **2** Wax resist **3** Salt
4 Wet-on-dry **5** Sponging **6** Spattering

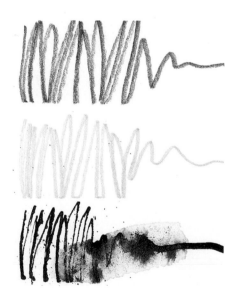

Pencil/Ink Very light pressure is needed for a 3B pencil to make a dark tone that shows up the paper texture to a fair degree.
• A little more pressure is needed for a 3H pencil, which leaves a slight indentation.
• Steel nibs catch at the paper fibers more than expected. The side-to-side stroke is difficult, while the stroke against the nib width is easier.
• Water dissolves dry pen lines easily.

Ratings in brief

Absorbency	●●○○
Speed of absorbency	●○○○
Wet strength	●●●○
Amount of size	●●○○
Ease of correction	●●●●
Whiteness	●●○○
Roughness	●●○○
Uniformity of texture	●●○○
Cost	●●○○
Formats available	▰ ▪ ◎
Heaviest weight available	140 lb / 300 gsm

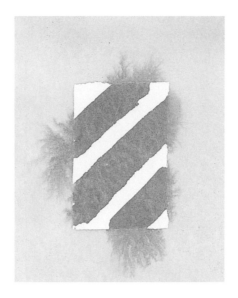

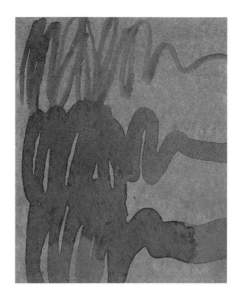

Flat wash/Granulated wash The paper seems to have just the right degree of absorbency. Colored washes brush on smoothly, with no feeling of friction between brush and paper.
• Washes dry flat, and at a moderate speed. The paint takes easily to the surface, showing no paper pinholes.
• Washes do granulate, and the effect achieved is subtle but consistent.

Wet-in-wet Wet-in-wet washes are relatively easy to control.
• When added to the damp yellow rectangle, red paint is very reluctant to blend and run into it without some physical encouragement.
• The paints blend slowly, with the resulting swatch drying to leave a subtle transition from red to yellow, without a hard watermark.

Brushmarks/Detail The paper texture is not that pronounced.
• All three brushes, the no. 2, no. 6, and ¼ in flat, feel very smooth and give long, paint-filled strokes.
• The marks hold their shape, and there is no noticeable sideways bleed.
• The brushmarks dry leaving a fine, but slightly granular, edge quality.

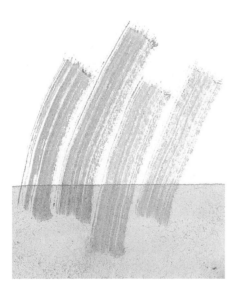

Dry brush The paper takes well to this technique.
• The surface is relatively smooth for a rough paper, and the brush moves fluidly over it.
• With the correct amount of paint loaded onto the brush, the strokes are long, with a very even flow of paint.

Masking The paper surface is relatively hard, making it ideal for masking.
• Both masking fluid and masking tape take easily and hold out paint with no bleed into unwanted areas.
• Tape and fluid can be removed easily, with no danger of tearing the paper surface.

Corrections/Sgraffito The hard sizing makes the rewetting and removal of paint a successful and straightforward operation, making corrections easy.
• Even very light scrubbing can remove a great deal of paint, with minimal raising of the paper fiber.
• Medium-grit sandpaper needs a slight degree of pressure to remove paint.
• A sharp scalpel makes fine lines, with little pulling at the paper.

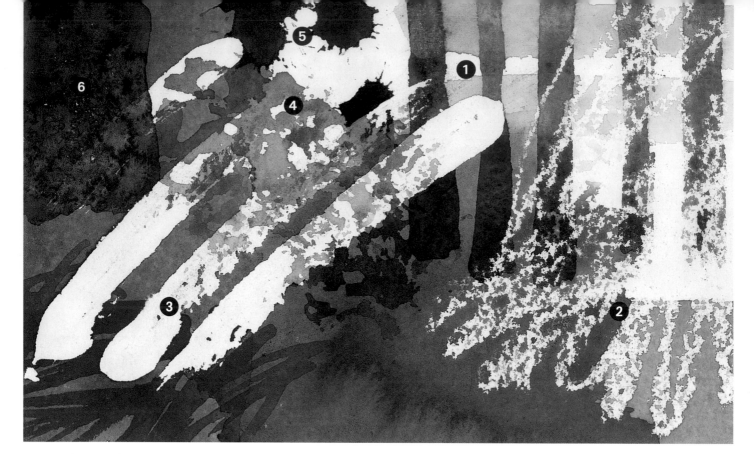

Rough surface papers: Twinrocker

200 lb (425gsm)

Handmade/4 natural deckles

Sheet size 22 x 30 in (560 x 760mm)

Twinrocker watercolor paper is one of many papers made at a small mill in Indiana, which was established in 1971. The paper is made from 100 percent cotton and linen fiber. It is sized by hand with hot gelatin, and is acid-free. The paper has four pronounced deckles, and is embossed with the Twinrocker logo in one corner. The surface is a bright white, with a moderately rough and irregular, tough, woven texture. Both sides are usable. The Twinrocker Company is unique in the many variations that it offers. It supplies many unusual sizes and shapes, as well as a wide variety of surfaces, colors, and thicknesses made to order.

This special paper feels a lot more substantial than it is, and is a treat to use. It stretches easily, but the pronounced deckles, attractive though they are, can prevent tape from adhering, and may need to be removed. The paper is reasonably absorbent, but colors stay crisp and bright even when overworked, and there is no noticeable lifting if a wet color is applied over a dry one. The paper is receptive to a full range of techniques, including wax resist, spattering, and sponging, and shows them to advantage.

■ **Montage of techniques: 1** Wet-on-dry
2 Wax resist **3** Masking fluid
4 Sponging **5** Spattering **6** Salt

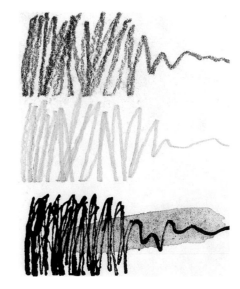

■ **Pencil/Ink** Minimal pressure from a 3B pencil leaves a dark tone.
• The 3H pencil needs greater pressure for even a light gray tone. There is no noticeable indentation.
• The pen nib catches the paper on the side-to-side stroke, delivering a steady flow of ink. The pen gives a fluid line when pulled against the nib width.
• The ink dissolves considerably when wet, drying to leave a granulated effect.

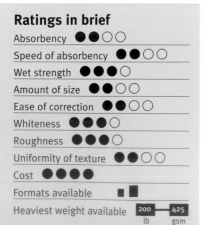

Ratings in brief

Absorbency	●●○○○
Speed of absorbency	●●○○○
Wet strength	●●●●○
Amount of size	●●●○○
Ease of correction	●●○○○
Whiteness	●●●●○
Roughness	●●●●○
Uniformity of texture	●●○○○
Cost	●●●●
Formats available	■ ■
Heaviest weight available	200 lb — 425 gsm

Flat wash/Granulated wash Washes take easily on the moderately absorbent surface. No pinholes of paper show through.
• The color dries rich, strong, and even, with no apparent sideways bleed. Work can progress at a steady pace without fear of streaking.
• Granulation occurs in the sizable patches of deeper texture, creating an open-texture effect.

Wet-in-wet Red paint spreads steadily into the damp yellow rectangle, but not equally in all directions.
• Insufficient yellow mixes back into the red to change the color greatly.
• When the movement stops, the paint dries with a mixture of very soft and more defined grainy edges.

Brushmarks/Detail Despite this paper's pronounced texture, it has a good capacity for detail. A no. 2 sable loaded with paint goes a long way and gives a fine stroke.
• The brushmark holds its shape with no sideways bleed, and dries with a crisp edge.
• The same is true of the no. 6 and the ¼ in flat.

Dry brush The paper lends itself well to dry brush work.
• Paint is so easily deposited on the surface that care is needed to prevent the brush from becoming too wet.
• When the right amount is used, the stroke is long and fine.
• Each bristle stands out on the paper surface.

Masking Tape and fluid are easy to apply and to remove.
• Even when pressed down firmly, the tape peels away without damaging the paper.
• Both tape and fluid leave overpainted areas with a crisp edge and no bleeding.

Corrections/Sgraffito Paint can be removed, but needs considerable scrubbing.
• The paper appears tough enough to withstand scrubbing without surface breakdown.
• Sanding removes the paint layer but quickly begins to raise and soften the fibers.
• A sharp knife point scratches relatively fine lines, but tends to pull the paper.

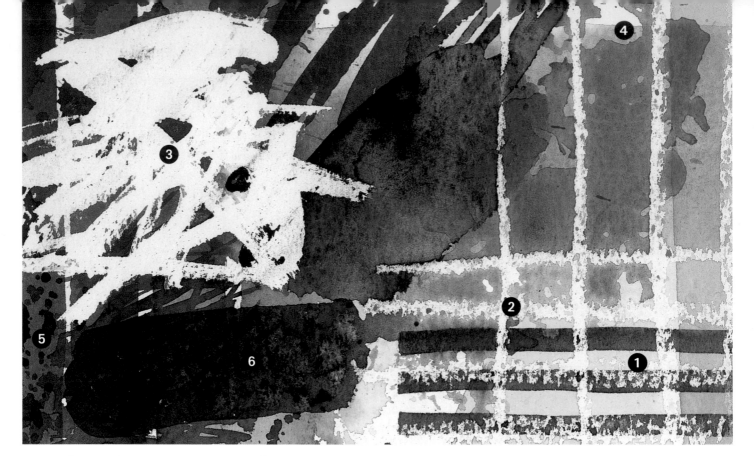

Rough surface papers: Bockingford Extra Rough

140 lb (300gsm)

Cylinder mold-made/ 4 cut edges

Sheet size 22 x 30 in (560 x 760mm)

This is a relatively new paper from St. Cuthberts Mill in Somerset, England. It is cylinder mold-made from high-quality wood pulp. The paper is acid-free, with a neutral pH, and is buffered with calcium carbonate to protect it from environmental contamination. It is internally sized, and supplied in only one weight.

The paper has a moderately random-textured surface. The reverse is smoother and similar to Bockingford Cold-pressed paper (see page 48). Both sides can be used. The paper is resistant to curling, but should be stretched. It stretches easily; adhesive tape sticks to it readily and does not lift. Painted washes are more successful if the paper is wetted and allowed to dry once before the paint is applied.

Bockingford Extra Rough is an easy paper to use. It combines all of the qualities found in the Bockingford Cold-pressed line, with the added dimension of a rougher surface. This makes it a good choice for work that uses a broader approach, and that may include some textural techniques.

Montage of techniques: 1 Wet-on-dry **2** Wax resist **3** Masking fluid **4** Sponging **5** Spattering **6** Salt

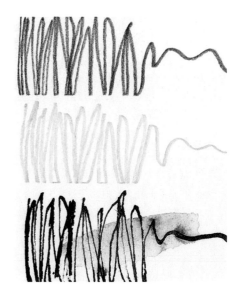

Pencil/Ink A 3B pencil travels smoothly across the surface but needs some pressure to leave a dark line. The paper texture is not evident.
• The 3H needs considerable pressure to leave a faint line, with some indentation.
• A steel-nib pen catches on the paper fibers and feels stiff. The stroke against the nib is a little smoother.
• Water washed over the dry ink lines softens and spreads the ink only slightly.

Ratings in brief

Absorbency	●●○○
Speed of absorbency	●●○○
Wet strength	●●●○
Amount of size	●●○○
Ease of correction	●●●●
Whiteness	●●●○
Roughness	●●●○
Uniformity of texture	●●●○
Cost	●○○○
Formats available	■
Heaviest weight available	140 lb — 300 gsm

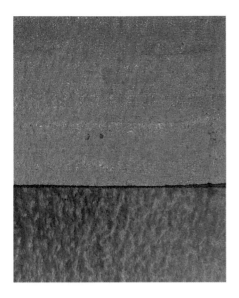

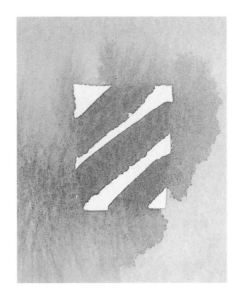

Flat wash/Granulated wash Washes glide on, with no abrasion between brush and paper.
• Washes lie flat, and the paint dries with a tiny variation in tone between the peaks and troughs of the texture.
• Granulated washes succeed well, allowing the surface texture to show through.

Wet-in-wet The red paint spreads steadily into the damp yellow rectangle, mixing slowly.
• No yellow pushes back into the red brushmarks.
• The swatch dries with a deep orange watermark over one half of its area, and a more subtle transition from red to yellow over the remainder.

Brushmarks/Detail All three brushes feel smooth and responsive.
• The paper takes the paint easily, allowing for long, fluid strokes.
• Brushmarks hold their shape with no noticeable sideways bleed.
• The marks dry to a relatively crisp, slightly broken edge.

Dry brush This technique succeeds well.
• The paper's workability, coupled with its moderately rough surface, results in a fairly subtle build-up of well-differentiated marks.
• The strokes are long, and the paper has sufficient sizing to allow the paint to spread before soaking in.

Masking Masking fluid brushes on easily.
• When overpainted and removed, it leaves a sharp edge; no paint seeps beneath to spoil unpainted areas.
• The fluid is easy to remove with gentle rubbing.
• Masking tape also leaves a crisp line. Care is needed during removal to avoid tearing the surface.

Corrections/Sgraffito Rewetting and gentle scrubbing removes a considerable amount of dry-washed paint without affecting the surface.
• Sandpaper rubs away the surface easily, but softens and raises the paper fibers.
• It is possible to scratch very fine lines into the paintwork, using a sharp frisket knife or craft knife blade.

Montage of techniques: 1 Wet-on-dry
2 Wax resist **3** Masking fluid
4 Sponging **5** Spattering **6** Salt

Rough surface papers: Arches Aquarelle

300 lb (640gsm)

Cylinder mold-made/4 deckles

Sheet size 22 x 30 in (560 x 760mm)

Arches paper is produced by Arjo Wiggins in France. It is machine mold-made, using 100 percent cotton fiber. The paper is tub-sized with gelatin and sized internally. It has a neutral pH and mildew protection. It is watermarked ARCHES FRANCE and chopmarked AQUARELLE ARCHES, making it easy to identify. The surface is off-white and rough, with a fairly pronounced but irregular texture. Both sides can be used; the texture on the back is slightly rougher and more regular. The paper stretches without problems; it can also be used without stretching.

This is an impressive paper. Its thickness, firmness, and texture make it ideal for location work in imperfect conditions. In the heavier weight of 400 lb (850gsm), it can be used without a drawing board. The paper is hard-sized, and performs better when the surface is wetted, then allowed to dry once before painting.

Instead of sitting on the surface, the paint settles into the paper, making removal and corrections difficult. The paper can sustain a range of techniques, including heavy color build-up and multiple washes. There is no noticeable lifting of a dried paint layer when it is overlaid with a wet layer. Colors remain crisp and dry very bright, with excellent saturation.

This paper is available in weights of 90 lb (185gsm), 140 lb (300gsm), 260 lb (356gsm), and 400 lb (850gsm).

Ratings in brief

Absorbency	●●○○
Speed of absorbency	●●●○
Wet strength	●●●●
Amount of size	●●●○
Ease of correction	●●○○
Whiteness	●●○○
Roughness	●●●○
Uniformity of texture	●●○○
Cost	●●●●
Formats available	■ ■
Heaviest weight available	400 lb — 850 gsm

Pencil/Ink When medium pressure is applied, a 3B pencil gives a dark tone. The pencil glides, making no indentation.
• A 3H pencil, applied with medium pressure, gives a pale gray line. The paper texture is less evident, with no discernible indentation.
• Stroking side-to-side, the nib catches on the paper fibers. Stroking against the nib's width is more fluid.
• When rewet, the dried water-soluble ink dissolves little.

Flat wash/Granulated wash The surface is moderately absorbent and absorption is consistent, so paint leaves the brush quickly and spreads easily.
• The paint dries very flat with only a slight variation in tone in the deeper recesses of the textured surface.
• Washes can be applied unhurriedly without fear of streaking.
• Granulated washes dry uniformly, leaving a subtle, even effect.

Wet-in-wet When red paint touches the damp yellow rectangle it spreads fairly quickly, at a steady pace in all directions.
• Enough yellow mixes back into the red to alter its color to orange.
• Where the mixing stops, a ghostlike image marks the transition from one color to another.

Brushmarks/Detail The paper has a good capacity for detail, given its texture. Brushes pull slightly at the surface, but allow for a high degree of control.
• The no. 2 sable leaves a fine line, but empties of paint quickly; the no. 6 does as well. There is no apparent sideways bleed with either brush.
• The ¼ in flat delivers more paint, but the brushmark holds its shape. When dry, its edge has a grainy quality.

Dry brush Paint is sucked quickly from a flat bristle brush.
• The paint picks up the surface peaks, creating an attractive subtle effect that could be used to advantage.
• Overfilling the brush can diminish the effect because the paint is delivered to the paper too quickly.

Masking Fluid application is straight-forward, but fine detail is difficult because the slightly raised surface fibers create a broken, textured line. Using a thinner masking fluid would help.
• The fluid rubs off without damage to the paper surface.
• Masking tape also adheres well and leaves a clean, sharp image. Even when rubbed down hard, the tape peels away with minimal drag on the paper surface.

Corrections/Sgraffito This is a very tough paper. A painted wash will need considerable scrubbing before the paint will soften enough to be removed.
• Paint remains in the deeper texture, with no breakdown of the paper fiber.
• Sanding requires heavy pressure to reach paper level, and leaves a pleasant, textured effect.
• A fine blade creates delicate lines without tearing or pulling the paper.

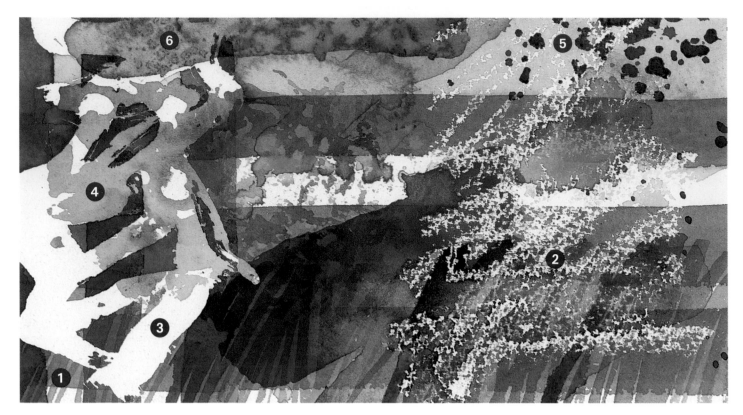

Rough surface papers: Fabriano Uno

140 lb (300gsm)
Machine mold-made/4 deckles
Sheet size 22 x 30 in (560 x 760mm)

Fabriano Uno is a fine paper from the oldest paper mill in Europe: the Cartiere Miliani Fabriano mill in Italy, where paper has been made since the 13th century. The company is said to have invented the watermark, and its original mark of a simple cross appears in this paper, along with the name FABRIANO UNO. The paper is machine mold-made from chlorine-free, natural, combed cotton. It is free of acid and of optical whiteners. The paper is internally and externally sized. It has four deckle edges, and its color is a creamy off-white. The paper is also available in the heavier weight of 300 lb (640gsm). Both sides are usable; the reverse has a more regular, slightly less pronounced pattern.

Adhesive tape sticks well, and the paper stretches easily. It takes all of the traditional watercolor techniques well, including wax resist, sponging, and spattering. Fabriano claims that this paper features the most recent advances in surface sizing, and the surface seems fairly hard.

■ **Pencil/Ink** A 3B pencil moves freely with minimal pressure, creating a dark line that reveals the paper texture.
• The 3H pencil needs slightly more pressure, and leaves a faint indentation.
• The steel nib catches slightly on the side-to-side stroke, but flows freely when pulled against the nib width.
• The water-soluble ink softens and dissolves quickly when rewet.

Ratings in brief

Absorbency	●●●○
Speed of absorbency	●●●●○
Wet strength	●●○○○
Amount of size	●●●●○
Ease of correction	●●○○○
Whiteness	●●○○○
Roughness	●●●●○
Uniformity of texture	●●●●
Cost	●○○○○
Formats available	■
Heaviest weight available	300 — 640
	lb gsm

Flat wash/Granulated wash Flat washes take to the surface easily, spreading consistently.
• A common characteristic of hard-sized paper, the paper doesn't show through.
• A faint abrasion is detectable as the brush passes over the textured surface, but is too slight to be a hindrance.
• Granulated washes work well, with a good separation of the pigments over the painted area.

Wet-in-wet The red paint spreads quite rapidly on the damp yellow rectangle, pushing the yellow before it rather than mixing with it.
• No yellow paint mixes back into the red to alter its color.
• The swatch dries with a mixture of soft and hard edges.

Brushmarks/Detail The capacity for detail is excellent. Even a small no. 2 brush moving rapidly across the surface produces crisp, fine lines.
• The same is true of the no. 6 and flat brushes. All leave marks that hold their shape with no sideways bleed and with crisp edges.

Dry brush Using this technique requires care, because the paper takes the paint a little too readily.
• Although rough, the surface is hard; no fibers stand proud, and the texture is close (compare this with the Fabriano Esportazione, page 24). The brush needs little paint, and the stroke must be relatively fast.

Masking Fluid is easy to apply, and it is possible to work finely with a small brush.
• The fluid is removed with minimal rubbing.
• Masking tape sticks easily, holds the paint to a crisp line, and unpeels with no pulling of the surface.

Corrections/Sgraffito Considerable scrubbing is needed to soften the paint and remove any from the surface.
• After heavy scrubbing, the surface shows no sign of deterioration.
• Sandpaper is more successful, scratching the surface before biting deeper and shaving off paper. A pleasant texture results.
• A sharp blade removes paint easily and can create fine lines.

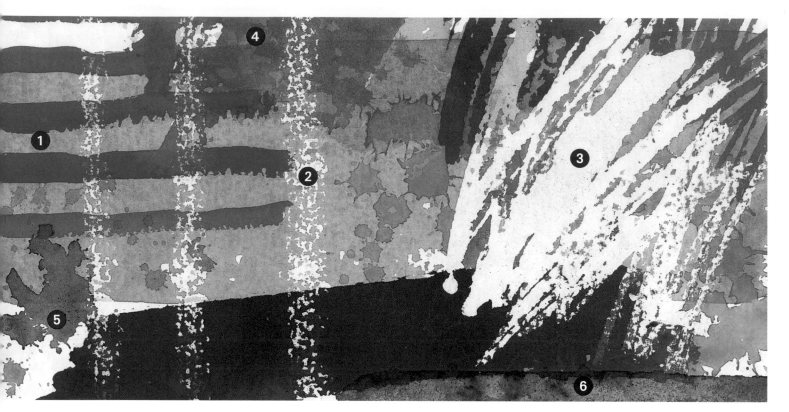

Rough surface papers: Fabriano Esportazione

140 lb (315gsm)

Handmade/4 natural deckles

Sheet size 22 x 30 in (560 x 760mm)

This is another superb paper from the Cartiere Miliani Fabriano mill in Italy. It is made from 100 percent cotton fiber, and has a neutral pH that provides resistance to aging. It is both internally and tub-sized with gelatin. The paper has four natural deckle edges, and carries the watermark C M FABRIANO HANDMADE. It is also available in weights of 90 lb (200gsm) and 300 lb (600gsm).

The surface has a random, woven texture, that is very pronounced due to the action of the coarse couching felts used in the production process. The paper is creamy white, and both sides are usable. It needs stretching to counter its tendency to cockle when wet. Stretching this paper is easy, and the paper dries tight and flat. Adhesive tape sometimes fails to stick adequately, however, so make sure that it is sufficiently wet. Despite its heavy texture, the paper is smooth, and takes washes readily. The paint remains wet long enough so that it can be manipulated or wiped off without any undue haste.

■ **Montage of techniques: 1** Wet-on-dry **2** Wax resist **3** Masking fluid **4** Sponging **5** Spattering **6** Salt

■ **Pencil/Ink** Medium pressure from the 3B pencil produces a dark but open-textured tone. The pencil travels a little stiffly and is not pleasant to use.
• The 3H pencil feels smoother, but needs heavy pressure to make its mark and leaves a slight indentation.
• The pen nib is difficult to control and feels uncomfortable.
• The ink dissolves little when rewet.

Ratings in brief

Absorbency	●●●○
Speed of absorbency	●○○○
Wet strength	●●●○
Amount of size	●●●○
Ease of correction	●○○○
Whiteness	●●○○
Roughness	●●●●
Uniformity of texture	●●●○
Cost	●●●●
Formats available	■
Heaviest weight available	300 lb — 600 gsm

Flat wash/Granulated wash Despite the heavy texture, the brush glides smoothly and delivers a very flat wash of color that is evenly distributed and dries bright and strong.
- The color may look darker in the deeper recesses; this is due to shadow, and not to a build-up of pigment.
- Granulation works fairly well; the granulated pigment collects in relatively large pockets within the texture.

Wet-in-wet Paint remains wet on the surface, so that fresh layers can be added for some time without causing watermarks or drying marks.
- The red paint spreads very slowly and uniformly into the yellow rectangle.
- The yellow does not mix back into the red.
- The dried wash shows a faint and gradual transition from one color to the other, with no hard edges or marks.

Brushmarks/Detail Detailed work is possible, but the texture affects the edge quality of the brushmarks.
- Fine work needs to be done slowly to accommodate the weave of the paper.
- Quick strokes tend to jump over the texture, leaving gaps. However, the brushwork looks fresh and free.
- All of the brushes deliver the paint smoothly, without noticeable sideways bleed.

Dry brush Even when the brush is relatively full, the textured surface takes only a limited amount of paint.
- The texture becomes apparent and the entire process is very smooth. There is none of the awkwardness that could occur with such a pronounced surface.

Masking Even the thicker brands of fluid paint on easily, leaving a crisp edge.
- Removal is equally simple, with minimum rubbing.
- Tape is just as successful; even when applied with pressure, it pulls off without leaving a trace.

Corrections/Sgraffito Despite the hard surface sizing, heavy scrubbing removes virtually no paint.
- The surface is extremely tough, and shows no sign of deterioration.
- Moderately heavy sanding removes little paint, but the resulting open texture is pleasant.
- A sharp blade catches and tears the paper fibers, and is difficult to control.

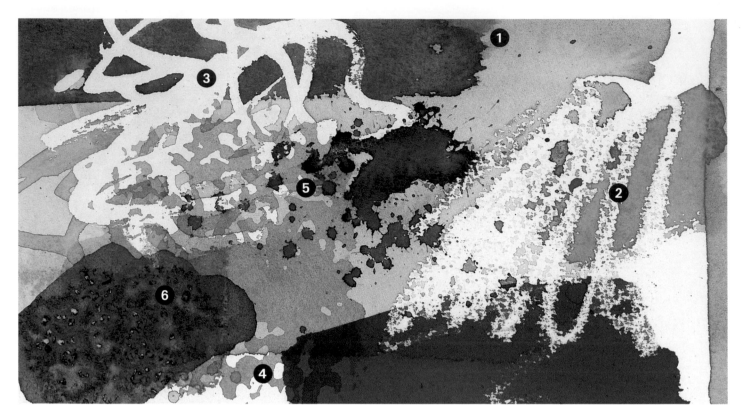

Rough surface papers: Lana Aquarelle

140 lb (300gsm)
Mold-made/2 deckles/2 torn edges
Sheet size 22 x 30 in (560 x 760mm)

Situated in eastern France, near Strasbourg, the Lana mill has been making paper for over 400 years. The paper is mold-made from 100 percent cotton, and is sized both internally and externally with gelatin, and buffered with calcium carbonate. It can be identified by the watermark LANAQUARELLE. The paper is sold by Winsor & Newton in the UK; these sheets are chopmarked WINSOR & NEWTON LANA. In the USA, the paper is available through Strathmore Artist Papers, and the sheets are chopmarked LANA.

Lana Aquarelle has two deckles and two torn edges, and its color is a bright off-white. Both sides of the paper can be used; the texture on the reverse is less pronounced than the texture on the front. It is also available in weights of 90 lb (185gsm) and 300 lb (640gsm). Adhesive tape sticks easily, and the paper stretches flat with no problem. The sizing is hard, and washes dry very bright. There is no noticeable lifting of color from one layer to another. The paper takes most watercolor techniques fairly well, including wax resist and sponging.

Montage techniques: 1 Wet-on-dry
2 Wax resist **3** Masking fluid
4 Sponging **5** Spattering **6** Salt

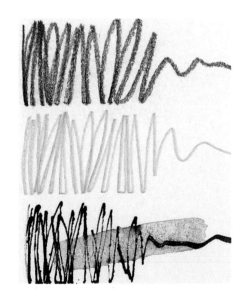

Pencil/Ink The 3B glides smoothly with light pressure, leaving a grainy, dark line.
• The 3H needs heavier pressure to produce an acceptably dense mark, and feels a little stiff. There is no indentation.
• The nib often catches on the paper. The side-to-side stroke leaves a stuttering line. The stroke against the nib's width is a bit better, but still uncomfortable.
• Water redissolves the ink, lightening the pen lines and staining the paper.

Ratings in brief

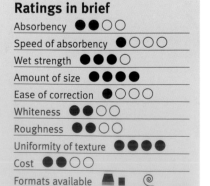

Absorbency	●●○○
Speed of absorbency	●○○○
Wet strength	●●●●○
Amount of size	●●●●
Ease of correction	●○○○
Whiteness	●●○○
Roughness	●●○○
Uniformity of texture	●●●●
Cost	●●○○
Formats available	▰ ▪ @
Heaviest weight available	300 — 640
	lb gsm

Flat wash/Variegated wash Washes are easy to apply; the paint brushes out well, and a brushful goes a long way.
• There is no noticeable abrasiveness or drag between brush and paper.
• Colors dry rich and strong. The texture is fairly pronounced when the paper is wet, but less so when the wash dries.
• Pigments granulate in the texture to give a regular, subtle effect.

Wet-in-wet The paint remains wet on the surface for some time.
• The red paint rushes into the damp yellow rectangle, pushing the yellow before it.
• No yellow paint mixes back into the red.
• The swatch dries with a bright orange watermark at the transition of yellow to red.

Brushmarks/Detail Although this is a rough paper, its texture is subtle and regular, making fine brushwork and detail easy.
• All brushes give a long brushstroke without lack of paint.
• Even when used quickly, each brush delivers a solid stroke with no gaps due to the texture.
• The brushmarks hold their shape with no sideways bleed.

Dry brush The texture picks up the paint easily, and a little goes a long way.
• Patience is the key; the brush must not be overloaded.
• With the correct paint ratio, it would be easy to build complex, highly textured passages.

Masking Even thick fluids brush on easily and come off without disturbing the paper.
• Overpainted fluid leaves a crisp edge.
• Masking tape also adheres with ease, and pulls from the paper without tearing the surface.
• Overpainting the tape also results in a sharp edge.

Corrections/Sgraffito Although the paper is hard-sized, repeated wetting and scrubbing fails to remove much paint.
• The surface is remarkably tough, however, and shows no sign of distress.
• Sandpaper works much better, removing the surface color and revealing white paper in a controlled way. The resulting texture is subtle and pleasant.
• Clean lines are easily scratched through the paint.

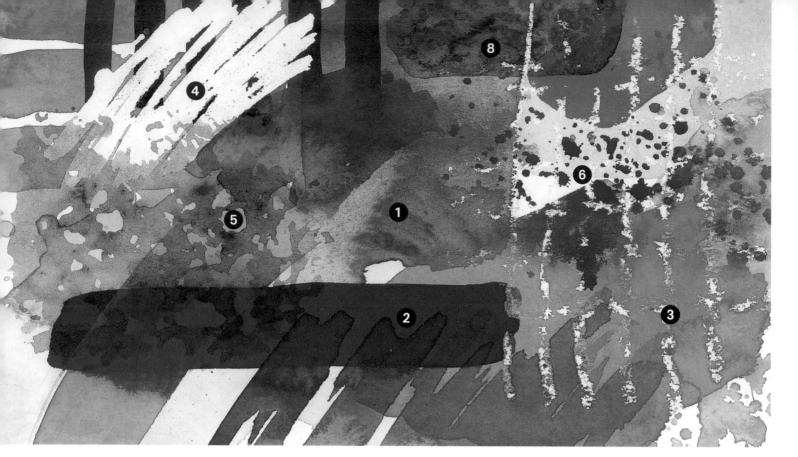

Rough surface papers: Schoellershammer 9T
120 lb (250gsm)
Machine mold-made/4 cut edges
Sheet size 20 x 28 in (510 x 720mm)

This is one of a line of artist's papers made at the Schoellershammer mill in Duren, Germany. It is medium-rough, but feels more like a Cold-pressed paper. Both sides are usable; the "right" side has a more random but scarcely discernible texture. The paper is manufactured from high-alpha cellulose pulp and cotton rag, and is a slightly creamy off-white color. It is chopmarked in one corner with the company logo, and with a number and letter code that identifies the type of surface. The paper has four cut edges. It has a neutral pH, and is internally sized. Stretching does not present a problem; adhesive tape sticks well, and the paper dries flat.

The paper copes easily with most techniques. Wax resist is a little disappointing, however, because the slight texture fills in too readily. Sponge marks hold their shape well, and so does spattered paint. Brushmarks dry with a crisp, but slightly darker edge. Colors dry very bright and layer well, with only an occasional pickup of a previously dried color. Washes often dry leaving watermarks, and backwashes occur frequently, however, both effects add interest to a surface that can seem flat and clinical.

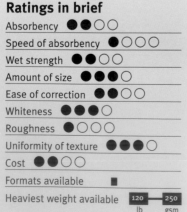

Ratings in brief

Absorbency	●●○○
Speed of absorbency	●○○○
Wet strength	●●○○
Amount of size	●●●○
Ease of correction	●●○○
Whiteness	●●●○
Roughness	●○○○
Uniformity of texture	●●●○
Cost	●●○○
Formats available	■
Heaviest weight available	120 lb — 250 gsm

Montage of techniques: 1 Wet-on-wet 2 Wet-on-dry 3 Wax resist 4 Masking fluid 5 Sponging 6 Spattering 7 Salt

Pencil/Ink A 3B pencil glides across the paper with minimum pressure, delivering a broken, dark tone. The texture shows clearly through the layer of graphite.
• The 3H needs greater pressure to give an even tone. There is no apparent indentation.
• A steel nib floats over the surface, and only very occasionally catches the paper.
• The ink dissolves hardly at all when rewet.

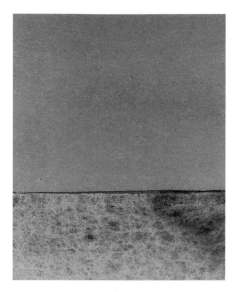

Flat wash/Granulated wash Paint flows easily onto the paper, drying brightly and crisply. The texture is barely noticeable.
• Care is needed to achieve a perfectly flat wash. The paint must be distributed evenly, or variations in drying time over the surface will produce drying marks.
• The paper's subtle texture becomes more evident when a granulated wash is applied; the pigments separate nicely, leaving a clear effect.

Wet-in-wet The red paint does not spread far into the damp yellow rectangle.
• Little, if any, yellow mixes back into the red.
• The transition where the colors merge is relatively subtle.

Brushmarks/Detail The paper has a high capacity for detail. All brushmarks hold their shape with no sideways bleeding of paint.
• The paint dries with a very sharp edge.
• It is possible to work quickly, and all three brushes delivered a smooth stroke.
• A brushful of paint goes a long way.

Dry brush Paint flows readily onto this paper, so care is needed not to overload the brush and deliver too much paint too quickly.
• The texture is so slight that it has minimal effect on the paint pickup.
• Once the paint ratio is right, the paper's potential for crisp detail enables a fine build-up of marks.

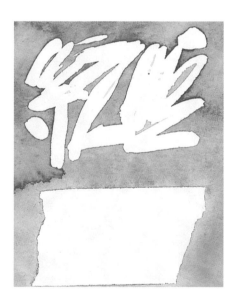

Masking Even the thicker masking fluids are easy to apply, making it possible to work minutely.
• The fluid is readily removed with gentle rubbing.
• Tape also adheres well and leaves a crisp mark when removed.
• There is no disturbance of the surface even when the tape is pressed down hard.

Corrections/Sgraffito This paper is extremely tough and hard. A substantial amount of scrubbing was needed before any paint was removed, and the surface remained unaltered.
• In order to remove any paint at all, sandpaper must be applied with considerable pressure. This leaves a random open-texture effect that would enliven a flat area.
• A blade point pulls at the surface slightly, but it is easy to make crisp lines.

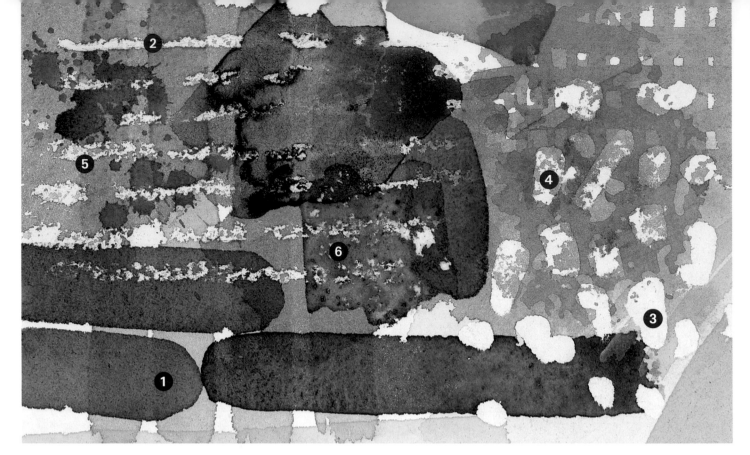

Rough surface papers: Zecchi

280 lb (600gsm)

Handmade/4 natural deckles

Sheet size 22 x 30 in (560 x 760mm)

This is one of a range of papers produced by a small, family-owned mill in Florence, Italy. The paper is made from 100 percent cotton rag, and is internally sized with resin. It is a bright off-white color, with a beautiful, pronounced, random-texture surface. Most papers from this mill carry the watermark ZECCHI FIRENZE, but this heavyweight paper is not watermarked. The paper is also made in weights of 90 lb (200gsm) and 140 lb (300gsm).

Both sides of the paper are usable; the texture left by the drying felts is evident on the reverse of the sheet. The paper's texture is more pronounced in appearance than in practice. Although it looks and feels substantial, it benefits from stretching. The deckles can prevent adhesive strip from sticking, so they should be removed first. The paper should be thoroughly soaked; if wetting with a sponge, be careful not to rub too hard. If the paper is to be used without stretching, it needs to be well soaked and allowed to dry first, to make it more receptive.

The entire range of watercolor techniques can be utilized on this paper, with potentially exquisite results. This is not an easy paper to work with, however, and practice is needed to realize its full capabilities.

Ratings in brief

Absorbency	●●○○○
Speed of absorbency	●●●●○
Wet strength	●●○○○
Amount of size	●●●○○
Ease of correction	●●●●○
Whiteness	●●●●○
Roughness	●●●●○
Uniformity of texture	●●○○○
Cost	●●●●
Formats available	▰ ▪ ▪ @
Heaviest weight available	280 — 600
	lb gsm

■ **Montage of techniques: 1** Wet-on-dry **2** Wax resist **3** Masking fluid **4** Sponging **5** Spattering **6** Salt

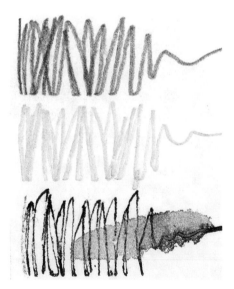

■ **Pencil/Ink** A 3B pencil needs some pressure to produce a uniform, dark tone. There is little evidence of texture, and only the faintest indentation.
• The 3H pencil needs a fair amount of pressure to make a light line, with a slightly more pronounced indentation.
• The nib feels strange and awkward. It catches on the paper with every stroke.
• The rewetted ink dissolves rapidly, stains the paper well, and markedly lightens the pen lines.

Flat wash/Granulated wash Washes brush on well, and the paint spreads and dries at an even rate across the surface.
- The brush pulls slightly at the paper texture.
- Washes dry a little lighter than anticipated, due to the white sparkle of paper showing through.
- Granulation is equally regular and subtle across the entire painted area, so it scarcely shows.

Wet-in-wet On touching the damp yellow rectangle, the red paint spreads slowly and fairly consistently in all directions.
- Hardly any yellow paint mixes into the red, so its color is unaffected.
- When dry, the swatch shows a subtle transition from one color to the other.

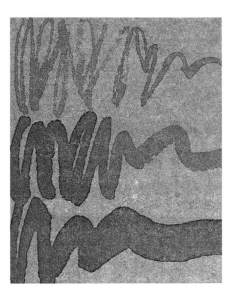

Brushmarks/Detail This paper accepts detail well.
- The surface feels soft, and causes the brush to drag slightly.
- The no. 2 sable brush leaves a fine brushstroke with a slightly broken edge.
- The two larger brushes produce similar results. There is a minimal amount of sideways bleed, but the strokes hold their shape and dry with a slightly grainy but crisp edge.

Dry brush The paper's texture, coupled with its habit of pulling at the brush, provides an excellent surface for dry-brush work—unexpected in view of its apparent roughness.
- Loaded with a fairly generous amount of paint, the brush produces a series of nicely separated and consistent long strokes.

Masking The paper's texture and slightly raised fibers make fine work difficult, unless the fluid is very thin.
- Using a larger brush and a bolder approach is best; the fluid takes easily, creating some interesting edges.
- The masking fluid is easily removed with minimal rubbing, but heavy applications can pull at the paper.
- Masking tape sticks well; it peels away with a slight pulling of the paper surface.

Corrections/Sgraffito Rewetting and scrubbing the paper softens the paint so much that the white surface is almost retrieved, making corrections easy.
- Caution is suggested, however, as the paper fibers may start to break down.
- Medium-grit sandpaper shaves off both paper and paint at an alarming rate; this technique must be done with care.
- A sharp blade catches and tears the paper if scratching is not done gently.

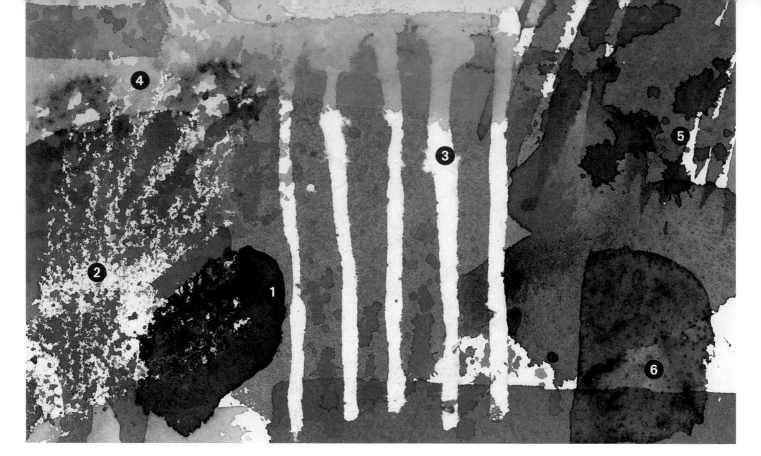

Rough surface papers: Larroque

200 lb (400gsm)

Handmade/4 natural deckles

Sheet size 22 x 30 in (560 x 760mm)

Moulin de Larroque is an old mill situated in the town of Couze, in southwestern France. One of two mills under the same ownership, it produces a range of very beautiful papers, using traditional methods. This Larroque paper has an irregular-textured, rough surface. The reverse is flatter and less granular, due to the action of the couching felts. Made from 100 percent cotton, the paper has a neutral pH, and it is internally sized only, which keeps the surface soft and absorbent. The sheet has four natural deckle edges, and comes in a bright off-white color. The same paper is available in a heavier 280 lb (600gsm) weight.

The paper stretches easily, and adhesive tape sticks well due to the lack of surface sizing. The absence of surface sizing has its downside, however: corrections are almost impossible, and the surface is easily damaged by masking fluid and tape, or by rubbing when wet. Nevertheless, this is an impressive paper; colors look bright and lively on its surface. A bit of planning and a sure hand are all that are needed to realize its considerable potential.

Montage of techniques: 1 Wet-on-dry **2** Wax resist **3** Masking fluid **4** Sponging **5** Spattering **6** Salt

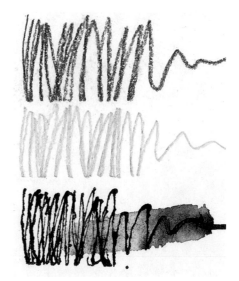

Pencil/Ink A 3B pencil, used with medium pressure, delivers a dark tone. The line is dense; little white is visible.
• A 3H pencil feels stiff and requires pressure to make a mark. The surface is soft, but there is little indentation.
• The nib catches on the side-to-side stroke, but less than expected.
• The ink dissolves quickly when rewet, spreading into the brushmark, but only lightens the pen lines a little.

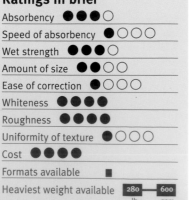

Ratings in brief

Absorbency	●●●○
Speed of absorbency	●○○○
Wet strength	●●●○
Amount of size	●●○○
Ease of correction	●○○○
Whiteness	●●●●
Roughness	●●●●
Uniformity of texture	●○○○
Cost	●●●●
Formats available	▪
Heaviest weight available	280 lb — 600 gsm

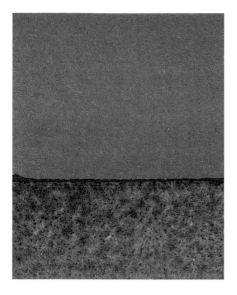

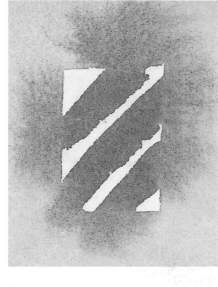

Flat wash/Granulated wash Washes brush on easily with little discernible drag from the surface.
• Washes have a uniform spread, and soak in and dry at a medium rate, with few pinholes apparent.
• The colors dry very bright, with no darkening of tone in the texture depths.
• Granulation occurs, but the effect is soft; with no surface sizing, the pigments have little time to separate.

Wet-in-wet On contact with the damp yellow rectangle, the red paint spreads slowly and subtly in all directions.
• It dries to leave a ghostlike transition from one color to the other.
• The yellow paint does not push back into the red, due to the absorbency of the paper.
• Watermarks or drying marks are unlikely to occur.

Brushmarks/Detail The paper holds brushmarks well, making some detail possible.
• The marks from all three brushes hold their shape with virtually no sideways bleed.
• The paper handles both fast and slow strokes equally well.
• The marks dry with a crisp but slightly granular edge.

Dry brush This technique works reasonably well. The paper is eager to take paint from the brush, however, so it is important not to overfill it.
• The correct amount of paint takes to the textured surface well.
• Quick strokes rather than ponderous ones distribute the paint more effectively.

Masking Care is needed with masking fluid and tape.
• Fluids go on easily, but when rubbed and removed thicker deposits tend to tear the paper.
• Tape behaves similarly; it sticks easily and results in a crisp line, with no bleeding beneath, but can pull and tear the surface if not removed with great care.

Corrections/Sgraffito Rewetting and washing off paint is almost impossible. Without surface sizing the paint soaks deep into the paper fibers.
• Scrubbing softens and removes some paint but also destroys the soft paper surface.
• Both sanding and scratching with a sharp blade succeed, if done gently.

Rough surface papers: Canson Montval / Torchon

125 lb (270gsm)

Machine mold-made

Sheet size 22 x 30 in (560 x 760mm)

The rough Canson Montval Torchon paper is a relatively new addition to the wide range of papers marketed by Papeteries Canson et Montgolfier for Arjo Wiggins, which is based in France. The paper is machine mold-made from 100 percent high-alpha cellulose. It is internally and surface-sized. It is a bright white, with a distinct rough surface grain that the makers describe as "snowy." The front of the paper is smoother than the back, and its surface has a slight sheen. The paper is acid-free, mildew- and rot-resistant, and contains no optical brighteners. It is only available in the 125 lb (270gsm) weight, that feels slightly more substantial than many other similarly weighted papers.

The paper stretches easily; adhesive tape sticks securely to the surface. The paper is also resistant to cockling. The heavy sizing creates a surface that behaves in many ways like a Hot-pressed paper: the paint sits high on the surface of the paper, and is easily removable by rewetting.

Montage of techniques: 1 Wet-on-dry **2** Wax resist **3** Masking fluid **4** Sponging **5** Spattering **6** Salt

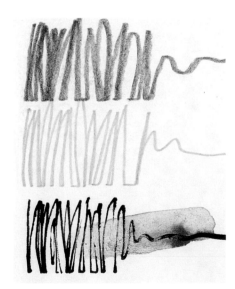

Pencil/Ink A 3B pencil feels smooth, but needs a fair degree of pressure to draw a dark line. The line has an open quality, with the paper fibers showing through.
• A 3H pencil also glides smoothly with pressure; it leaves a slight indentation.
• The nib catches a little but travels fairly smoothly in all directions.
• When rewet, the ink dissolves easily, lightening the pen lines and creating a fairly dark washmark.

Ratings in brief

Absorbency	●○○○
Speed of absorbency	●○○○
Wet strength	●●○○
Amount of size	●●●○
Ease of correction	●●●●○
Whiteness	●●●○
Roughness	●○○○
Uniformity of texture	●●●○
Cost	●○○○
Formats available	▬ ▪
Heaviest weight available	125 lb 270 gsm

Flat wash/Granulated wash The surface feels remarkably smooth for a Rough paper, and there is no friction between brush and paper.
• Washes brush on easily, but tend to puddle if too much is used, due to the hard sizing. Excess paint can be absorbed with a dry brush, or with a paper towel.
• The texture gives colored washes an agreeable, slightly mottled effect.

Wet-in-wet The hard surface causes the paint to behave much as it would on a Hot-pressed surface.
• The red paint rushes into the damp yellow rectangle, but puddles up.
• It dries with a fairly pronounced orange watermark.

Brushmarks/Detail The surface is capable of extremely fine brushwork. It is unusual in that it has none of the abrasiveness characteristic of most Rough papers.
• All of the brushes deliver a lot of paint to the surface and feel very responsive.
• The brushmarks hold their shape with no sideways bleed, and dry with a sharp, but slightly irregular, edge.

Dry brush This technique works satisfactorily, but little texture shows because of the large texture and smoothness of the surface.
• The paint brushes out well; a damp brushful goes a long way, and makes a clean mark.

Masking Masking fluid is both easy to apply and to peel off.
• When overpainted and removed, it leaves a sharp edge.
• Tape needs much more care, as it can easily tear the surface.

Corrections/Sgraffito Dry paint can be removed quite easily when rewet and scrubbed.
• The paper's surface stays intact; only after prolonged scrubbing does it feel a little rougher.
• Sanding must be done with caution. It removes the hard surface and reveals the softer fibers beneath.
• Scratching produces fine, controlled lines, but can also cause damage.

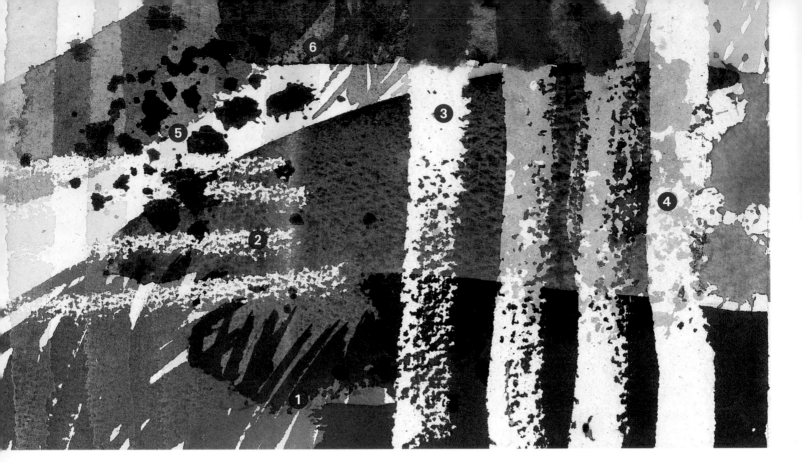

Rough surface papers: Khadi Indian Atlas

650 lb (400gsm)

Handmade/4 natural deckles

Sheet size 40 x 54 in (1000 x 1400mm)

Khadi takes its name from the handspun cotton yarn produced in villages all over India, and from the Khadi movement begun by Mahatma Gandhi in the 1930s to encourage village crafts and trades. Today Khadi paper is made in the Karnataka area of southern India. The paper is produced from 100 percent recycled long-fiber cotton rag, and is internally and surface-sized with gelatin. The paper has a natural pH. It is a creamy off-white, and has a pronounced rough surface produced by the coarse woollen drying felts. The sheet has four natural deckles. Both the front and back of the paper are usable; the texture of the back of the paper has a slightly more regular pattern than the front.

The large sheet size and rough texture make this paper eminently suitable for broad expressive work on a large scale. Because of its weight, the paper needs stretching to prevent it from cockling when wet. Stretching is easy, although adhesive tape can be difficult to stick on parts of the deckled edges of the paper. Washes take better if the paper is wetted once and allowed to dry before any paint is applied.

■ **Montage of techniques: 1** Wet-on-dry
2 Wax resist **3** Masking fluid
4 Sponging **5** Spattering **6** Salt

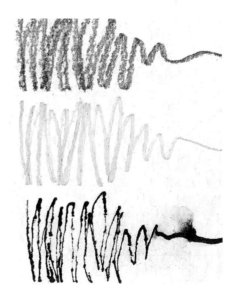

■ **Pencil/Ink** The surface feels soft; fairly heavy pressure is needed to produce a dark tone using a 3B pencil. The tone is broken, revealing the paper's texture.
• A 3H pencil requires even heavier pressure to make a faint mark, although there is no apparent indentation.
• A nib's side-to-side stroke constantly catches on the paper fibers. The stroke against the width is better, but still stiff.
• The dried ink hardly dissolves at all.

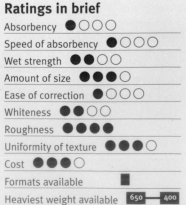

Ratings in brief

Absorbency	●○○○
Speed of absorbency	●○○○
Wet strength	●●○○
Amount of size	●●●●○
Ease of correction	●○○○
Whiteness	●●○○
Roughness	●●●●
Uniformity of texture	●●●○
Cost	●●●○
Formats available	■
Heaviest weight available	650 lb 400 gsm

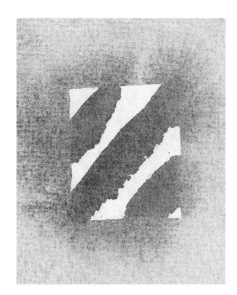

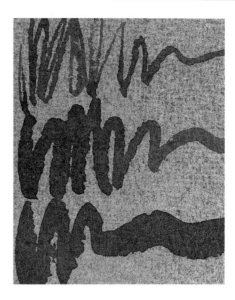

Flat wash/Granulated wash Washes flow on easily, with a tendency to show pinpricks of paper.
• Colors dry crisp and bright, with a pronounced variation in tone between the top of the paper texture and the bottom, where the paint collects and dries slightly darker.
• The same effect makes granulated washes successful, as the pigments separate and settle into the texture.

Wet-in-wet The paint appears to soak into the paper slowly and steadily.
• The red paint invades the damp yellow rectangle in equal directions.
• The yellow mixes back into the red and alters the color.
• The swatch dries with a faint, ghostlike transition from one color to another; there is no hard watermark.

Brushmarks/Detail Despite the rough texture, the paper takes and holds brushmarks well.
• The no. 2 sable floats over the surface, delivering paint steadily, so that very fine lines are possible.
• With larger brushes, the texture stops the paint from finding parts of the surface, causing broken-edged marks.
• The paint holds its mark with no sideways bleed.

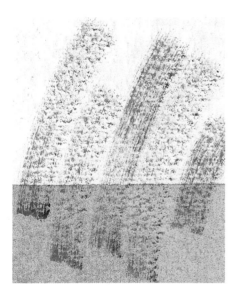

Dry brush The pronounced texture works well, taking just enough paint to create a broken mark.
• The apparently heavy sizing keeps the paint intake to a minimum. Highly detailed dry brushing could be difficult.

Masking Masking fluid takes easily, but the thickness of the liquid, coupled with the heavy texture, makes fine work difficult. Using a thinner fluid would help.
• Dried fluid is easily removed, with no tearing of the paper surface.
• Tape also adheres well; despite the paper's texture, it leaves a crisp, fine line when overpainted.
• Despite the paper's toughness, tape can tear it if removed carelessly.

Corrections/Sgraffito Despite the heavy sizing, paint can be difficult to remove.
• Rewetting and scrubbing soften the paint slightly, but the surface quickly starts to break down. The paint is pushed deeper into the fibers and the paper texture begins to flatten.
• Sanding works rapidly, removing the paint with minimum pressure. Caution is needed to avoid flattening the texture.
• Scratching is surprisingly effective.

More papers...

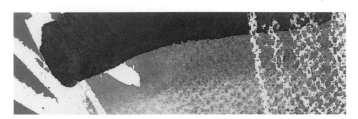

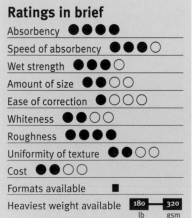

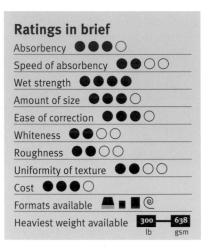

Ratings in brief

Absorbency	●●○○		
Speed of absorbency	●●●●		
Wet strength	●●○○		
Amount of size	●●●○		
Ease of correction	●●●○		
Whiteness	●●●○		
Roughness	●●●○		
Uniformity of texture	●●●○		
Cost	◐○○○		
Formats available	■ ■		
Heaviest weight available	140 lb — 300 gsm		

Zirkall Aquarag

140 lb (300gsm)/
mold-made/4 deckles/
sheet size 22 x 30 in
(553 x 760mm)/
watermark Zirkall

This German-made paper is very pleasant to use. Colors look bright on the very white surface that allows paint to be washed off quite easily. Masking tape can tear the paper surface if removed without taking due care. This internally sized paper is made from 100 percent cotton, and is also available in a 100 lb (200gsm) weight. Both sides are usable.

Ratings in brief

Absorbency	●●●●		
Speed of absorbency	●●●●		
Wet strength	●●●●		
Amount of size	●●●○		
Ease of correction	●●●●		
Whiteness	●●○○		
Roughness	●●●○		
Uniformity of texture	●●○○		
Cost	●●●○		
Formats available	■ ■ ■ @ @		
Heaviest weight available	300 lb — 638 gsm		

Saunders Waterford

300 lb (638gsm)/mold-made/4 deckles/sheet size 22 x 30 in (560 x 760mm)

Made by St. Cuthberts Mill in England, this paper is very tough, and is easily used without stretching. It is also available in 95 lb (190gsm), 140 lb (300gsm), and 180 lb (356gsm) weights. Both sides of the paper can be worked on. It takes all traditional watercolor techniques, but take care when removing masking tape.

Ratings in brief

Absorbency	●●●●		
Speed of absorbency	●●●○		
Wet strength	●●●○		
Amount of size	●●○○		
Ease of correction	●○○○		
Whiteness	●●○○		
Roughness	●●●●		
Uniformity of texture	●●○○		
Cost	●●○○		
Formats available	■		
Heaviest weight available	180 lb — 320 gsm		

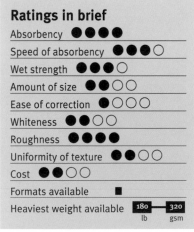

Moulin de Pen-Mur

180 lb (320gsm)/handmade/
4 deckles/sheet size 20 x 26 in (500 x 650mm)

A very absorbent paper from a small French paper mill, the texture and feel of this paper are similar to the Indian Khadi papers. The paper takes most watercolor techniques, but care should be taken with masking fluid and tape, otherwise they can tear the surface. Care should also be taken when making corrections by scrubbing at dry paint by rewetting. Both sides of the paper are usable.

Bloxworth

140 lb (300gsm)/machine mold-made/4 cut edges/
sheet size 22 x 30 in (560 x 760mm)

This paper has quite a distinct surface texture, left by the couching felts. It is an easy paper to use, and takes all traditional watercolor techniques. Care needs to be taken when removing masking tape; if the surface begins to tear, it can lift over a large area. Paint can be washed off easily, making corrections straightforward. The paper is also available in a 95 lb (190gsm) weight.

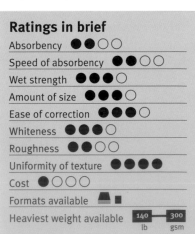

Ratings in brief

Absorbency	●●○○		
Speed of absorbency	●●○○		
Wet strength	●●●○		
Amount of size	●●●○		
Ease of correction	●●●○		
Whiteness	●●●○		
Roughness	●●○○		
Uniformity of texture	●●●●		
Cost	●○○○		
Formats available	■ ■		
Heaviest weight available	140 lb — 300 gsm		

Canson Fontenay

140 lb (300gsm)/mold-made/2 torn edges/
2 deckle edges/sheet size 22 x 30 in (560 x 760mm)/
watermark Fontenay

This paper works well with all traditional watercolor techniques. Colors look bright on the surface, and corrections can be made easily by washing off paint. Take care not to tear the paper's surface when removing masking tape. Made from 50 percent cotton and 50 percent high-quality cellulose, the paper is both internally and surface-sized.

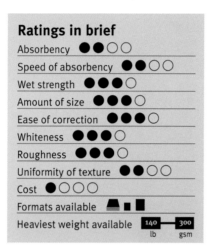

Ratings in brief

Absorbency	●●○○
Speed of absorbency	●●○○
Wet strength	●●●○
Amount of size	●●●○
Ease of correction	●●●○
Whiteness	●●●○
Roughness	●●●○
Uniformity of texture	●●○○
Cost	●○○○
Formats available	▰ ■ ■
Heaviest weight available	140 lb / 300 gsm

Velke Losiney

180 lb (360gsm)/handmade/4 deckles/
sheet size 22 x 30 in (560 x 760mm)

Situated in the Czech Republic, the Velke Losiney Mill was founded in 1596. The mill has had a colorful history, with one former owner's wife being burned at the stake for practicing witchcraft. The paper is made from a mixture of cotton and flax, and the sheets are heavily sized. The paper is very bright and accepts all traditional watercolor techniques. Care should be taken not to scrub too heavily when washing off color, or the surface can start to deteriorate. The paper is also available in a 130 lb (280gsm) weight.

Ratings in brief

Absorbency	●●○○
Speed of absorbency	●●●○
Wet strength	●●○○
Amount of size	●●●○
Ease of correction	●●○○
Whiteness	●●●○
Roughness	●●○○
Uniformity of texture	●●●○
Cost	●●●○
Formats available	■
Heaviest weight available	180 lb / 360 gsm

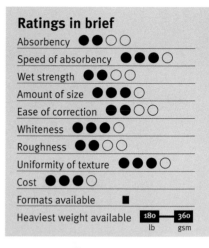

Schut Flamboyant

115 lb (250gsm)/machine mold-made/2 cut edges/
2 torn edges/sheet size 22 x 30 in (560 x 760mm)

This paper has an agreeable, extra-rough surface that has the potential for some spectacular effects. It is made from 50 percent cotton and 50 percent top-quality cellulose. Textural effects work very well, but take care when removing masking tape, because it can tear the surface. Overwetting the paper and scrubbing too hard can result in some fiber breakdown. The reverse side of the paper is completely smooth, without any texture at all.

Ratings in brief

Absorbency	●●○○
Speed of absorbency	●●○○
Wet strength	●●●○
Amount of size	●●○○
Ease of correction	●○○○
Whiteness	●●●○
Roughness	●●●○
Uniformity of texture	●○○○
Cost	◐○○○
Formats available	▰ ■ ■
Heaviest weight available	115 lb / 250 gsm

Ratings in brief

Absorbency	●●○○
Speed of absorbency	●●○○
Wet strength	●●●○
Amount of size	●●○○
Ease of correction	●●○○
Whiteness	●●○○
Roughness	●●●○
Uniformity of texture	●●○○
Cost	●○○○
Formats available	■ ■
Heaviest weight available	281 lb / 600 gsm

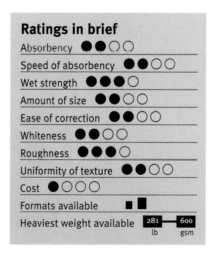

Fabriano Artistico

140 lb (300gsm)/
mold-made/2 deckles/2 torn edges/
sheet size 22 x 30 in (560 x 760mm)/
watermark C M Fabriano 100-100 Cotton

Made from 100 percent cotton at the Fabriano mill in Italy, this paper is very smooth to use, despite its pronounced texture. It is moderately absorbent, and accepts all traditional watercolor techniques, including masking and wax resist, very well. The reverse side of the paper is slightly smoother, but it is also usable . The paper is also available in 100 lb (200gsm) and 300 lb (600gsm) weights.

Working with Rough surface paper

Paintings made on Rough paper will often benefit from a looser approach. Let the paint work with the characteristics of the chosen paper on its own terms; mixing and blending with little interference will result in a fresh, sparkling work.

Materials

- Waterford Rough surface 300 lb (640gsm) paper
- 2B pencil
- No. 10 round sable brush
- No. 4 round sable brush
- Flat ½ in (12.5mm) brush

■ **Thin wet-in-wet** Working over a light, loose pencil sketch, the general shapes of the flower leaves and petals are blocked in using a no. 10 sable brush. The unstretched, dry paper is initially a little resistant to the thin washes of paint, and these dry leaving a broken-edge effect. A small gap is left between those washes that are not intended to mix together. Working wet-into-wet in this way allows for the work to be built up showing the subtle color changes in the leaves and petals.

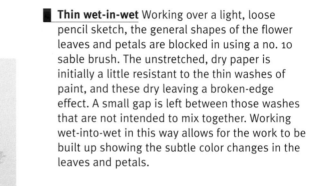

■ **Texture** The rough, heavily textured surface of this unstretched paper, evident in the unpainted top lefthand half of the sheet, adds a certain sparkle to the paintwork, with colors staying crisp and bright. The paint does not soak in immediately, allowing for easy removal and manipulation. The rough texture is responsive to dry brushwork.

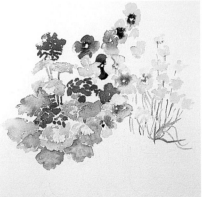

Thicker wet-in-wet The spread of thinner washes worked wet-in-wet is often unpredictable. By working with slightly thicker paint and smaller brushes, it is possible to have a greater degree of control over the spread. This technique is perfect for showing the pattern of colors seen within the pansy heads.

Granulation The problem of representing both the color and texture of the old terracotta pots is solved by using earth colors mixed with various blues. This combination granulates easily on the rough paper. A flat ½ in brush is used to pull a darker mix around the flower pots, depicting the cast shadows and the round forms of the pots themselves.

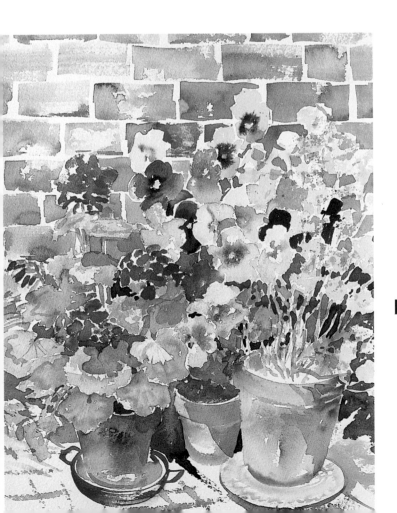

Kay Ohsten Pansies and Geraniums
Rough paper

Once the flowers and pots are dry, the brickwork of the wall behind is painted. Using the flat brush, the texture of the bricks is represented with a mixture of dry-brush work and much wetter strokes, textured by blotting off with absorbent paper roll. When dry, the painting is finished by working wet-on-dry to tighten up and redefine the shapes, using darker washes that both sharpen the focus and give the image greater depth.

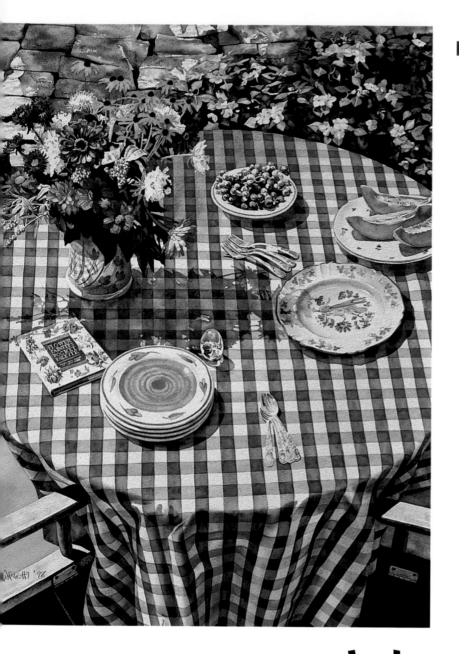

William C. Wright
High Summer Banquet with Melon

Strong color washes worked using a combination of wet-on-dry and wet-in-wet sit well on this Arches paper. The paper was not stretched for this painting; it was simply tacked to a board by its corners.

cold-pressed papers

Cold-pressed papers are also known as papers that are not Hot-pressed, or simply as "Not." They have a degree of texture that, depending on the paper, can be quite pronounced. They are sized internally, and are invariably surface-sized. This sizing allows for some absorbency, and enables paint to be manipulated while wet to a much greater degree than with Rough papers. The sizing allows washes to lie relatively flat, but watermarks can and will occur if more paint is used than needed, and it is allowed to puddle. Colors can lack bite and intensity, but this can be remedied by making mixes a touch brighter than required.

Characteristics:
Has a slight texture that is somewhere in between rough and smooth. The surface is slightly grained and dull. Can be matte, unglazed, or eggshell.

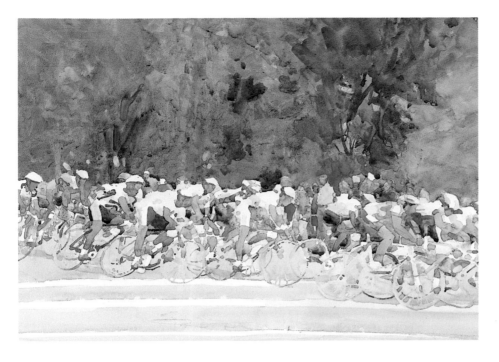

Anne Adams Robertson
■ Tour Dupont I

The white of the paper has been cleverly used to act as the white jerseys and helmets of the racing cyclists. Precisely placed colors merging the riders and spectators create a feeling of speed.

Marc A. Castelli
■ Lark Light/Island Lark

The Cold-pressed paper surface is perfect for the degree of precision called for in this painting. Painting into a previously rendered drawing, the artist used color washes with carefully chosen values, worked wet-on-dry.

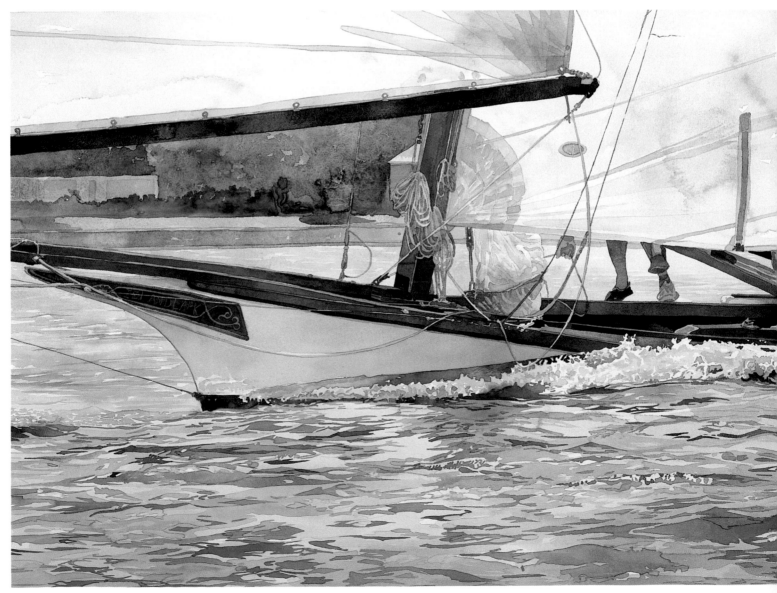

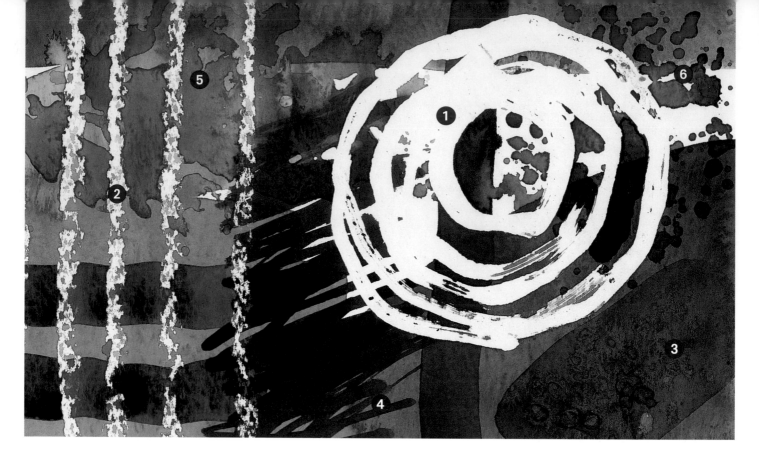

Cold-pressed papers:
Strathmore Watercolor 400 Series
140 lb (300gsm)

Machine-made

Sheet size 22 x 30 in (560 x 760mm)

The 400 Series is another range of papers manufactured by the Strathmore Company in Westfield, Massachusetts. This mid-range paper is machine-made from blended wood pulp. It is acid-free and has a neutral pH. The paper is only available with a Cold-pressed surface. It is hard-sized, meaning that absorption is kept to a minimum, with little staining of the paper fibers. This factor helps with manipulating washes, and makes lifting paint and corrections relatively easy exercises.

The paper is a creamy off-white, and is also available in five tints: Sand, Tundra Green, Sunset Snow, Arctic Ice and Warm Gray. It has a random Cold-pressed surface pattern, and is slightly smoother on the reverse side, which is also usable. The paper stretches easily, and is also available in a 200 lb (426gsm) weight.

■ Montage of techniques:
1 Masking fluid **2** Wax resist **3** Salt
4 Wet-on-dry **5** Sponging **6** Spattering

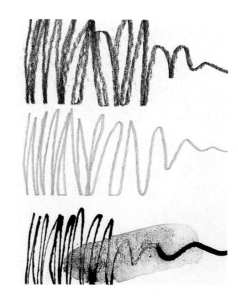

■ Pencil/Ink A soft, 3B pencil needs only light pressure to deliver a very dark tone that shows the paper texture.
• A harder, 3H pencil needs a bit more pressure and leaves some indentation on the paper surface.
• A steel nib feels both smooth and responsive, regardless of how it is used.
• Dry ink redissolves easily when wet, and can be removed almost entirely.

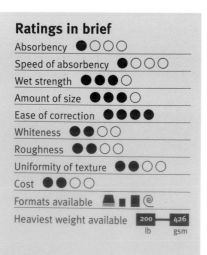

Ratings in brief

Absorbency	●○○○
Speed of absorbency	●○○○
Wet strength	●●●○
Amount of size	●●●○
Ease of correction	●●●●
Whiteness	●●○○
Roughness	●●○○
Uniformity of texture	●●○○
Cost	●●○○
Formats available	▲ ▪ ■ @
Heaviest weight available	200 lb — 426 gsm

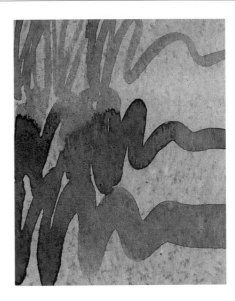

Flat wash/Granulated wash Washes brush on smoothly, with no noticeable friction between the brush and paper.
• The heavy sizing makes the paint sit on the surface of the paper with minimal absorption. Any resulting water and drying marks are minimized by removing any excess, and by not allowing the paint to puddle.

Wet-in-wet The paper offers a fair degree of control with this technique.
• When it touches the damp yellow rectangle, the red paint is reluctant to mix, and pushes into the yellow very slowly.
• The red paint then makes some attempt to push into the yellow, and the swatch dries with a subtle transition from one color to the other.

Brushmarks/Detail The paper takes detail very well.
• All three brushes, the no. 2, no. 6, and the ¼ in flat, feel smooth and responsive, and deliver long, fast strokes.
• The brushmarks hold their shape with no sideways bleed, and dry leaving a sharp edge.

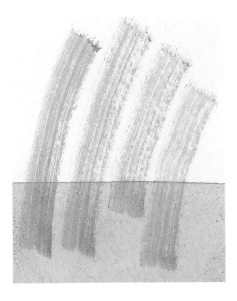

Dry brush This technique works extremely well on this paper.
• The paper has sufficient texture to work with the brush, but is smooth enough to allow long, steady strokes.
• The hard sizing resists any quick absorption, making it easy to brush out the paint.

Masking Masking fluid brushes on easily, and it is possible to do very fine work.
• Once dry, washes are held off the paper with no bleed, and the dry fluid is easily removed, with no pulling at the paper surface.
• The same results can be achieved with masking tape.

Corrections/Sgraffito Due to the hard sizing, it is almost possible to reach white paper.
• Rewetting dry paint with clean water and gently scrubbing removes the paint easily. The paper fibers are undamaged, and subsequent washes take well.
• Some pressure is needed to remove any paint with sandpaper, but the resulting texture is very pleasant.
• A scalpel makes very fine lines by scratching through the paint.

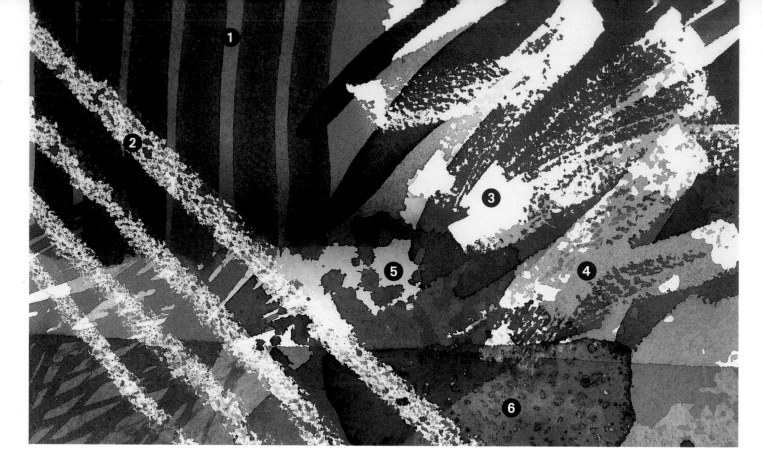

Cold-pressed papers: Whatman

200lb (400gsm)

Machine mold-made/2 natural deckles/2 torn edges

Sheet size 22 x 30 in (560 x 760mm)

The Whatman company has made paper in England for over 250 years. Its original handmade watercolor paper was held in high regard by artists throughout the 18th and 19th centuries. Handmade production ceased in 1962, but in the 1980s the company launched a new line of papers that has established its own following.

This paper is machine mold-made, using 100 percent cotton. It has a neutral pH, and is therefore acid-free. The paper is internally sized at the pulp stage and receives no surface sizing. The Cold-pressed surface reveals a subtle, fairly regular texture from the drying felts. The reverse has a less pronounced texture, but the pattern of the felts is more visible. The paper carries the WHATMAN watermark and logo. It has two natural deckles, and the remaining sides are torn. The paper is also supplied in the lighter weights of 90 lb (185gsm) and 140 lb (290gsm)

The paper needs stretching, and this is easily done. Adhesive tape sticks well and does not lift. Despite the relatively smooth, Cold-pressed surface, the paper can be made to show textural effects using masking fluid, wax resist, salt, and sponging. Colors are vivid and crisp on the bright white surface.

Montage of techniques: 1 Wet-on-dry
2 Wax resist **3** Masking fluid
4 Sponging **5** Spattering **6** Salt

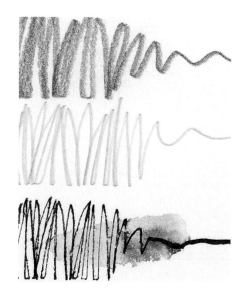

Pencil/Ink Pressure is needed to achieve an even, dark tone using a 3B pencil.
• A 3H also pencil needs pressure to produce an even, light gray line that leaves a slight impression.
• The nib snags fairly readily on the side-to-side stroke, but is smooth when pulled against its width.
• The rewetted ink dissolves and spreads, but the effect is minimal.

Ratings in brief

Absorbency	●●○○○
Speed of absorbency	●●○○○
Wet strength	●●●○○
Amount of size	●●○○○
Ease of correction	●●●●○
Whiteness	●●●●○
Roughness	●●○○○
Uniformity of texture	●●●●○
Cost	●●●●
Formats available	▰ ▪
Heaviest weight available	200 —— 400
	lb gsm

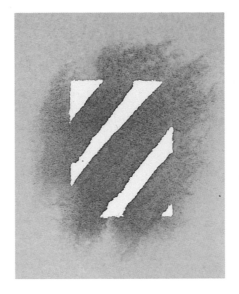

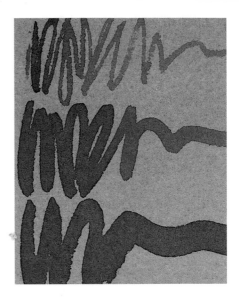

Flat wash/Granulated wash The brush floats smoothly across the paper, applying washes with ease.
• Washes soak in and dry at a medium rate.
• Tiny pinpricks of paper show through sporadically, but are barely discernible.
• The washes dry bright and very flat.
• Granulation is subtle because texture is slight.

Wet-in-wet Red paint moves very slowly and only marginally into the damp yellow.
• It blends and dries to a ghostly edge, with no watermark or drying mark.
• The yellow paint shows no sign of pushing back into the red.

Brushmarks/Detail The paper holds brushmarks well, despite its absorbency.
• A no. 2 sable delivers a slightly blurred stroke, and runs out of paint quickly.
• The no. 6 and the $\frac{1}{4}$ in sable deliver more paint, and it goes farther.
• All marks hold their shape with minimal bleed.
• Fast strokes tend to have a broken edge where the paint misses parts of the paper.

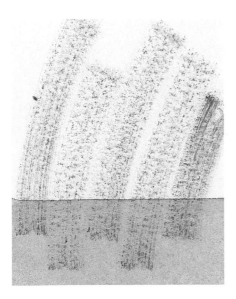

Dry brush Dry brush succeeds well once the best paint-to-paper ratio has been worked out.
• The key is to build the desired effect patiently, with a little paint at a time.
• Overloading the brush would fill the stroke, as the paint would be sucked into the absorbent paper.

Masking A liquid mask is easily applied, but leaves a slightly broken edge when overpainted. Thinner fluid would help.
• The fluid comes away relatively well with rubbing, but thicker deposits pull the surface.
• Tape can also cause tears; use caution. When overpainted, tape leaves a crisp line.

Corrections/Sgraffito Paint is easily removed by rewetting and scrubbing the surface.
• The surface is not especially delicate, but will deteriorate if rubbed too hard.
• Sanding needs to be fairly vigorous to remove any paint, but too much pressure flattens the paper tooth and softens the surface.
• A sharp blade pulls on the fibers, but with care, precise marks are possible.

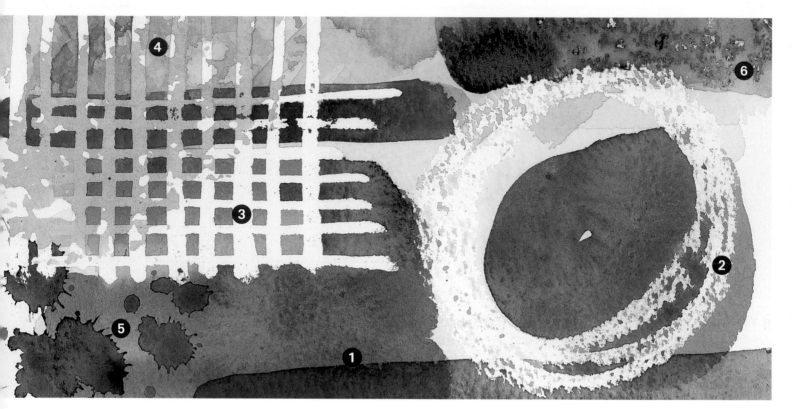

Cold-pressed papers: Bockingford

200 lb (425gsm)

Cylinder mold-made/4 cut edges

Sheet size 22 x 30 in (560 x 760mm)

Bockingford paper comes from the St. Cuthberts Mill in Somerset, England. It is cylinder mold-made from a very pure, high-quality wood pulp. The paper is acid-free with a neutral pH, and is buffered with calcium carbonate, that gives it archival permanence and protection against environmental contamination. It has a random, slightly textured, Cold-pressed surface. The reverse side, which is also usable, is somewhat smoother, and it has a marginally more regular surface texture. The paper is internally sized, and has four cut edges. It is supplied in five weights: 72 lb (150gsm), 90 lb (190gsm), 140 lb (300gsm), 200 lb (425gsm), and 250 lb (535gsm). The middleweight 140 lb (300gsm) paper is also available in a range of attractive colors: cream, gray, oatmeal, eggshell (green), and blue.

The paper stretches well; adhesive strip sticks readily, and the paper is resistant to cockling. The heavier weighted papers can be used without stretching, but all of the papers appear to be more receptive if wetted with water and allowed to dry just once prior to painting. The paper is easy to use; it is quite forgiving, and takes all watercolor techniques well. Colors look fresh and bright, and multiple wash layers are possible. The same paper is available through Daler-Rowney under the name Langton.

Ratings in brief

Absorbency	●●○○
Speed of absorbency	●●○○
Wet strength	●●●○
Amount of size	●●○○
Ease of correction	●●●●
Whiteness	●●●○
Roughness	●●○○
Uniformity of texture	●●●○
Cost	●○○○
Formats available	▰ ▪ @
Heaviest weight available	250 — 535 / lb gsm

Montage of techniques: 1 Wet-on-dry **2** Wax resist **3** Masking fluid **4** Sponging **5** Spattering **6** Salt

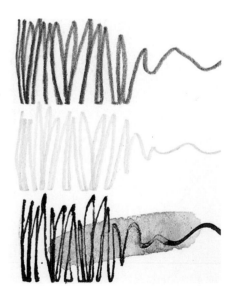

Pencil/Ink A 3B pencil delivers a smooth dark line with minimum pressure, revealing little of the paper texture.
• Fairly heavy pressure on the harder 3H gives a uniform pale gray line and causes pronounced indentation.
• A nib catches slightly on the side-to-side stroke, but glides against its width.
• Water brushed over the dry ink softens and lightens the pen lines considerably.
• The ink wash dries leaving a good tone.

Flat wash/Granulated wash Washes brush on smoothly, with no abrasion between brush and paper.
• Colors dry and soak into the fibers at a uniform rate across the wash area.
• Paint dries with watermarks if allowed to puddle, but any excess is easily removed with a dry brush or paper towel.
• There is sufficient texture to provide a fair amount of granulation.

Wet-in-wet The red paint spreads steadily and slowly in all directions upon contact with the damp yellow rectangle.
• It mixes equally, but only slightly, with the yellow.
• The paint dries with no watermarks. The result is an attractive, indistinct transition of colors.

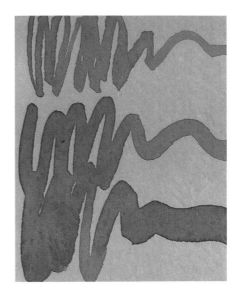

Brushmarks/Detail All of the brushes feel responsive and smooth.
• They all deliver a consistent amount of paint over the area of the stroke.
• The brushmarks dry with a sharp edge and no sideways bleed.
• The paper is an excellent choice for detailed work but also has sufficient texture for open, expressive painting.

Dry brush This technique works very well on this paper.
• The combination of surface texture and workability enables easy and consistent results.
• The strokes are long and nicely broken, conveying a fresh, open feeling.
• As always, the key is not allowing the brush to become overloaded.

Masking Fluid is smooth to apply and removes with gentle rubbing.
• Overwashing results in crisp marks with no sign of bleeding.
• Tape sticks easily and also makes a sharp edge when overpainted. Care is needed when lifting the tape, to avoid tearing the surface.

Corrections/Sgraffito Paint softens when rewet and can be removed with gentle scrubbing.
• Signs of breakdown appear only after considerable heavy scrubbing.
• Sandpaper quickly shaves off a thin layer of paint and paper, and leaves a nice open texture.
• Small areas can be removed by gentle scratching with a sharp blade.

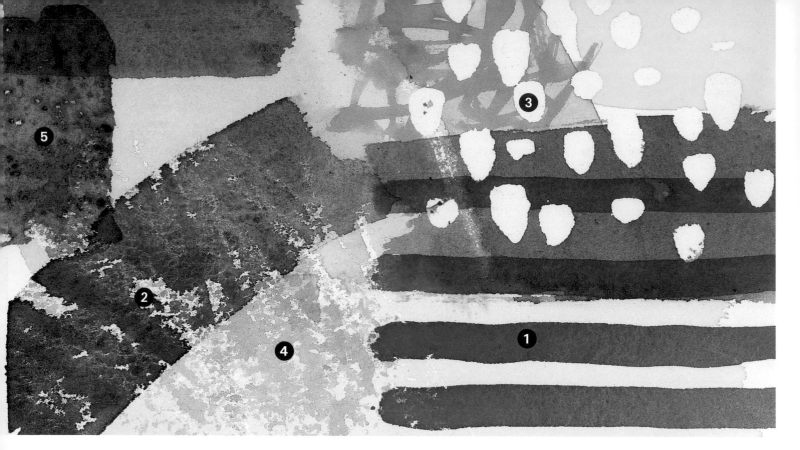

Cold-pressed papers: Saunders Waterford

300 lb (638gsm)

Cylinder mold-made/2 natural deckles/2 torn edges

Sheet size 22 x 30 in (560 x 760mm)

St. Cuthberts Mill in Somerset, England, has been making fine papers for over 250 years. This watercolor paper currently produced by the mill has a distinguished pedigree: its predecessor was the T H Saunders watercolor paper used by artists all over the world. Today, this paper holds the Royal Watercolour Seal of Approval.

The paper is cylinder mold-made from 100 percent long cotton fiber, which makes it very strong and resistant to cockling. The paper is acid-free and buffered with calcium carbonate that gives added protection against environmental contamination. It is internally sized and externally tub-sized. The surface is a slightly creamy off-white. Two edges have natural deckles, and the other two are simulated by tearing. It carries the watermark SAUNDERS WATERFORD, and is chopmarked at one corner with the St Cuthberts Mill logo and the words WATERFORD SERIES. The paper is available in a wide range of weights: 90 lb (190gsm), 140 lb (300gsm), 260 lb (536gsm), and 300 lb (638gsm).

The 300 lb (638gsm) paper can be used without stretching, but the lighter weights benefit from it. Adhesive strip sticks well, and the papers stretch without any problem. The surface has a subtle, slightly granular texture, that is similar both in the front and in the back. Both sides are usable.

Montage of techniques: 1 Wet-on-dry 2 Wax resist 3 Masking fluid 4 Sponging 5 Salt

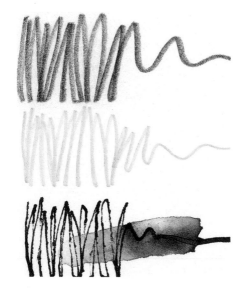

Pencil/Ink
A 3B pencil feels smooth and leaves a dense, dark line, showing little surface texture.
• A 3H pencil needs some pressure, and leaves only a light line, but with pronounced indentation.
• A steel nib is fairly smooth on a side-to-side stroke, and very smooth when used against the nib's width.
• The ink dissolves well, lightening the pen lines and leaving a strong tone.

Ratings in brief

Absorbency	●●○○
Speed of absorbency	●●○○
Wet strength	●●●○
Amount of size	●●●○
Ease of correction	●●○○
Whiteness	●●○○
Roughness	●●○○
Uniformity of texture	●●○○
Cost	●●●○
Formats available	🖼 ◼ 🌀
Heaviest weight available	300 lb — 638 gsm

Flat wash/Granulated wash The paper feels very smooth; a brush glides over it.
• Washes take easily, and dry bright and even, with no streaking or pinpricks.
• The paper's absorbency appears quite high, unusual in a heavily sized paper. This factor helps washes to go on flat.
• Granulation occurs, but the effects are uniform and subtle, bringing out the paper's texture.

Wet-in-wet Red paint added to the damp yellow mixes spreads slowly and evenly in all directions.
• It dries to produce a soft transition from one color to the other.
• The yellow paint makes the red brushmarks more orange.
• The swatch dries without watermarks.

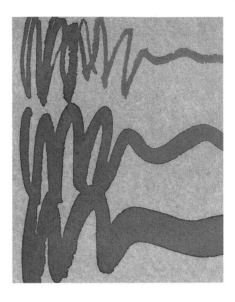

Brushmarks/Detail The paper has a great capacity for detail due to its combination of smoothness and receptiveness.
• All of the brushes travel the surface without noticeable friction.
• Even fast strokes make solid marks that hold their shape and have a slightly granular edge quality when dry.

Dry brush The paper is remarkably receptive to dry brushing.
• It seems to take just the right amount of paint from the brush, even when it is slightly overfilled.
• A fairly brisk stroke works best, leaving a regular pattern of marks that pick up and reveal the random weave.

Masking Liquid and tape are easily applied to the hard surface.
• When overwashed, they leave crisp edges, making delicate work possible.
• The fluid is removed with gentle rubbing, and the tape peels away without raising the fibers.

Corrections/Sgraffito Rewetting and scrubbing removes some paint, but less easily than expected.
• The surface is tough, however, and there is no danger of the paper deteriorating.
• Sanding needs care, because it raises the fibers and softens the surface considerably.
• It is possible to scratch sharp lines with little snagging.

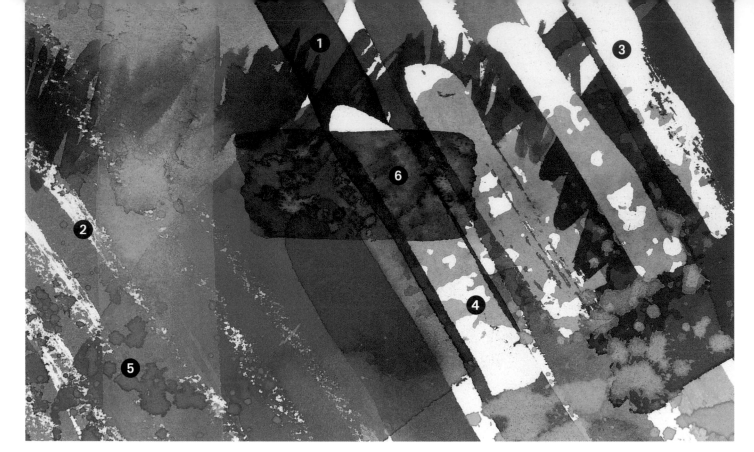

Cold-pressed papers: Arches Aquarelle

140 lb (300gsm)

Mold-made/2 natural deckles/2 torn edges

Sheet size 22 x 30 in (560 x 760mm)

This paper is made in France at the Arches mill, in the town of the same name. The mill is now part of the Arjo Wiggins group, also based in France.

The paper is mold-made from 100 percent cotton fiber. It is acid-free, and receives an anti-fungus treatment. Internally sized and externally tub-sized with natural gelatin, the sheets are air-dried and hand-inspected. The surface is creamy white, with a subtle, irregular texture. The texture on the reverse of the sheet shows the indistinct pattern of the couching felts. Both sides are usable. There are two natural deckles, and the other two sides are torn. The paper is easily identifiable; it carries the watermark ARCHES FRANCE, and is chopmarked in one corner AQUARELLE ARCHES. The paper is available in five weights: 90 lb (185gsm), 140 lb (300gsm), 260 lb (356gsm), 300 lb (640gsm) and 400 lb (850gsm). The lighter weights of paper need stretching.

The Arches Cold-pressed papers are perhaps the most popular choice of artists, and it is easy to see why. The paper stretches easily, and colored washes spread and dry flat and bright. A new layer does not soften the dry color below, so that many layers can be applied before the colors begin to dull. Most watercolor techniques, including salt, sponging, masking, and wax resist, are successful and trouble-free.

Montage of techniques: 1 Wet-on-dry 2 Wax resist 3 Masking fluid 4 Sponging 5 Spattering 6 Salt

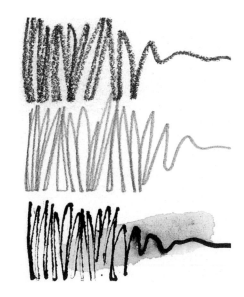

Pencil/Ink Medium pressure results in a dark line using a soft 3B pencil. Some white shows, revealing the texture.
• The 3H needs hard pressure to leave a mid-gray tone, with no indentation.
• The nib catches a little on the side-to-side stroke, and the ink is slightly reluctant to flow. The stroke against the nib width is smoother, giving a good line.
• Water does not dissolve much ink; the pen lines stay dense.

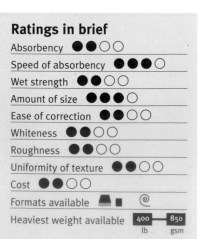

Ratings in brief

Absorbency	●●○○○
Speed of absorbency	●●●●○
Wet strength	●●○○○
Amount of size	●●●●○
Ease of correction	●●○○○
Whiteness	●●○○○
Roughness	●●○○○
Uniformity of texture	●●○○○
Cost	●●○○○
Formats available	
Heaviest weight available	400 lb — 850 gsm

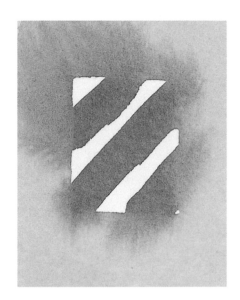

Flat wash/Granulated wash The paper feels slightly rough under the brush, but washes glide on smoothly, drying bright and very flat.
• The paper texture is barely noticeable; there are none of the pinpricks to which hard-surface size paper can be prone.
• Washes granulate and the pigments separate, but the effect is minimal.

Wet-in-wet The red paint spreads evenly into the damp yellow rectangle, mixing with the yellow rather than pushing it back.
• There is no discernible penetration of the yellow into the red.
• The swatch dries with a very gradual transition from one color to the other, and with no hard watermarks.

Brushmarks/Detail The paper has an excellent capacity for detail, although fast brushwork sometimes skips over the paper tooth, giving the mark a slightly broken edge.
• Slower brushing leaves a crisp mark with sharp edge quality and no sideways bleed. The paint stays where it is put.
• All of the brushes deliver paint easily over a wide area before needing to be recharged.

Dry brush This technique works exceptionally well on this paper.
• Building a web of marks is easy and quick, thanks to the paper's fine texture and slightly absorbent surface.
• As usual with dry brushing, it is important not to overfill the brush.

Masking The hard paper surface makes masking with tape and liquid trouble-free.
• Fine work is possible, since both masking materials leave crisp edges when overpainted.
• The fluid is removed with gentle rubbing, and the tape leaves the paper cleanly, even when pressed down hard.

Corrections/Sgraffito Despite the hard sizing, concentrated scrubbing was needed to remove any paint. The surface can withstand heavy punishment.
• Sanding removes only a little paint, leaving a subtle texture.
• Fine lines or highlights are easy to scratch through the paint with a sharp knife.

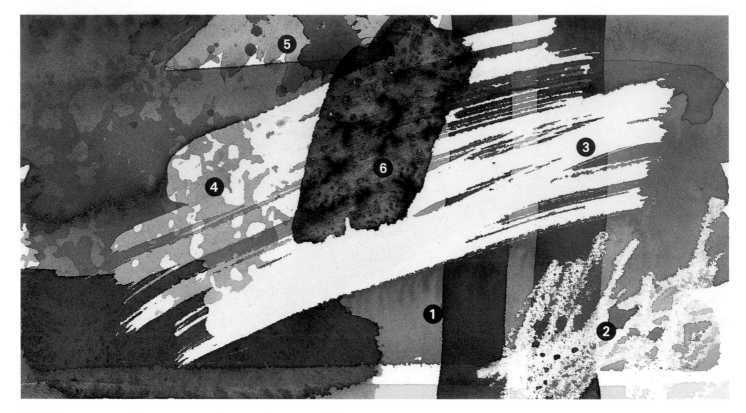

Cold-pressed papers: Lana Aquarelle

140 lb (300gsm)

Mold-made/2 natural deckles/2 torn edges

Sheet size 22 x 30 in (560 x 760mm)

This paper is mold-made from 100 percent cotton at the Lana mill, situated in France, and carries the LANAQUARELLE watermark. It is internally sized, and also externally sized with gelatin. The paper possesses a neutral pH, and is buffered with calcium carbonate to provide some protection against environmental contaminants. The sheet is a bright off-white, with a very smooth-textured surface. The reverse is slightly smoother; both sides are usable. It has two true deckle edges and two torn edges.

The paper is available in three weights: 90 lb (185gsm), 140 lb (300gsm), and 300lb (640gsm). The two lighter weights need stretching, but the heavier-weight paper can be used unstretched. Stretching presents no problem.

Washes dry very bright on this hard-sized paper. Colors layer well, with no pickup from previous applications, and washes are easy to manipulate. All of the usual watercolor techniques succeed on the paper, which is quite forgiving. It is an ideal choice for both the beginner and the more experienced watercolor artist.

Montage of techniques: 1 Wet-on-dry
2 Wax resist **3** Masking fluid
4 Sponging **5** Spattering **6** Salt

Pencil/Ink A 3B pencil glides smoothly and leaves a dark line, showing just a hint of the paper's texture.
• The 3H pencil is less smooth; it needs some pressure and leaves a fairly noticeable indentation.
• A nib stutters slightly when used side-to-side, but does not dig in or tear the paper. It is smoother against its width.
• Water brushed over the penwork removes virtually no ink.

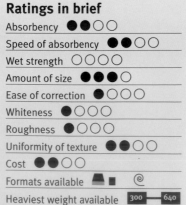

Ratings in brief

Absorbency	●●○○○
Speed of absorbency	●●○○
Wet strength	○○○○
Amount of size	●●●○
Ease of correction	●○○○
Whiteness	●○○○
Roughness	●○○○
Uniformity of texture	●●○○
Cost	●●○○
Formats available	▬ ■ @
Heaviest weight available	300 lb / 640 gsm

Flat wash/Granulated wash The paper is very smooth, and the texture is only just discernible through the brush.
• Washes glide on; a brushload of paint goes a long way.
• Care is needed to remove any excess paint, which can cause drying marks.
• The granulation effect is practically invisible.

Wet-in-wet The red paint spreads into the damp yellow very slowly, but continues to creep for some time.
• The spread is not equal in all directions.
• Very little yellow travels back into the red.
• The paint dries without watermarks and shows a barely perceptible shift of color.

Brushmarks/Detail The paper is an excellent choice for detail and fine brushwork.
• Even fast strokes deliver a consistent and solid mark, that holds its shape and has no sideways bleed.
• All of the brushes spread so much paint that the stroke seems to go on forever.
• The brushes float easily and feel very responsive.

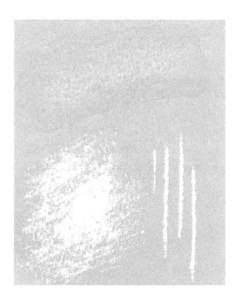

Dry brush This technique works like a dream on this paper.
• Each brushstroke delivers a long, open mark, with every bristle apparent.
• Avoid the temptation to rush by overfilling the brush; this would create a solid mark because of the paper's receptivity.

Masking As with so many of the hard-sized Cold-pressed papers, fluid and tape are trouble-free.
• Both create sharp edges, with no paint bleeding beneath to spoil the desired effect.
• Both peel away, with no disturbance of the paper fiber.

Corrections/Sgraffito Rewetting and scrubbing removes little paint, but the hard surface can withstand vigorous treatment without a breakdown of fiber.
• Sandpaper quickly reaches clean paper; care is needed not to flatten the subtle tooth completely.
• Fine scratching is easy as well, but digging too deep can tear the fibers.

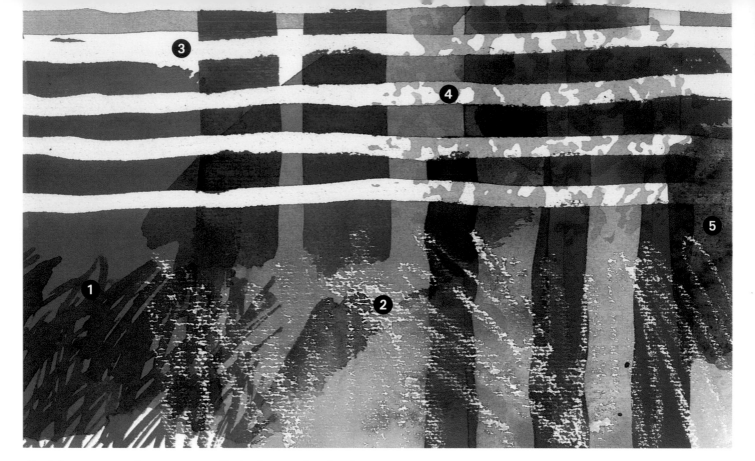

Cold-pressed papers: Fabriano Artistico

140 lb (300gsm)

Mold-made/2 natural deckles/2 torn edges

Sheet size 22 x 30 in (560 x 760mm)

Made by the Fabriano mill in Italy, this off-white paper has a distinctive texture. Although it is a wove paper, it looks like a laid one, with a regularly lined surface resembling an artist's canvas. This texture is due to the pattern impressed by the couching felts on the wet paper. The paper is made from 100 percent cotton linters, and is acid-free to protect against aging. It is surface-sized, and has two natural deckles and two torn edges. It is identified by the watermark C M FABRIANO 100/100 COTTON. It is made in three weights: 90 lb (200gsm), 140 lb (300gsm), and 300 lb (600gsm).

The paper cockles when wet, and benefits from being stretched. Stretching presents no difficulty; adhesive tape sticks easily and the paper dries flat. The paper absorbs paint and water fairly quickly, but colors sit high and bright on the surface. Washes are successful; there is little noticeable pickup of dry color when overlaid with wet. The paper takes fine brushwork well, but textural effects such as wax resist struggle to make any impact.

■ **Montage of techniques: 1** Wet-on-dry
2 Wax resist **3** Masking fluid
4 Sponging **5** Salt

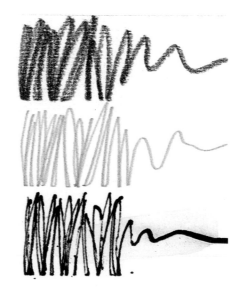

■ **Pencil/Ink** Little pressure is needed to make a dark line with the 3B pencil, that glides over the paper. The graphite emphasizes the surface texture.
• A 3H pencil needs medium pressure and feels less smooth.
• A steel nib is relatively smooth, but snags a little on the side-to-side stroke.
• The stroke against the width of the nib feels fluid, leaving a line of varied width.
• The rewet ink seems not to dissolve.

Ratings in brief

Absorbency	●●○○○
Speed of absorbency	●●○○○
Wet strength	●●○○○
Amount of size	●●●●○
Ease of correction	●●○○○
Whiteness	●○○○○
Roughness	●●○○○
Uniformity of texture	●●●●●
Cost	●○○○○
Formats available	■
Heaviest weight available	300 — 600
	lb gsm

Flat wash/Granulated wash The paper feels smooth beneath the brush and flat washes flow on easily.
- The paint spreads well and the surface absorbs it at a moderate rate.
- Flooding the paper will result in drying marks, so excess paint must be removed.
- The lined surface becomes very evident when color is applied.
- Granulated washes appear to disguise the paper texture.

Wet-in-wet The yellow rectangle is rapidly absorbed. The red paint, applied shortly after, spreads quickly into the yellow, mixing gradually.
- The swatch dries without a watermark.
- No yellow paint pushes back into the red.
- To avoid watermarks, paint must be manipulated while quite wet.

Brushmarks/Detail The paper enables a high degree of detail.
- The paper's texture does not interfere with brushwork, which always feels smooth and responsive.
- All of the brushes deliver a lot of paint and distribute long strokes.
- Brushmarks keep their shape with no sideways bleed, and dry with a crisp edge.

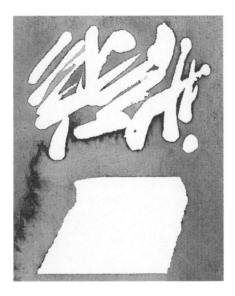

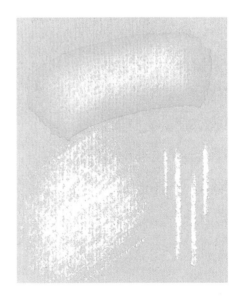

Dry brush The ease of spread, combined with the slight texture, makes dry brush reasonably successful.
- The technique tends to disguise the paper's linear pattern.
- The brush can easily be overloaded; use the minimum amount of paint possible.

Masking Fluid brushes on with ease, and a little goes a long way.
- Delicate work is possible, even with the thicker fluids.
- Removal of fluid leaves a clean edge with no bleeding.
- Tape behaves in the same way, leaving a sharp edge.
- There is no surface pulling, even when the tape is applied firmly.

Corrections/Sgraffito Rewetting and scrubbing removes some paint, but must be concentrated, due to the paper's absorbency.
- Overly vigorous scrubbing begins to break up the paper fibers.
- Sanding merely scratches the surface at first, but with a little pressure, more paper is removed.
- A sharp blade etches fine lines, but digs in under too much pressure.

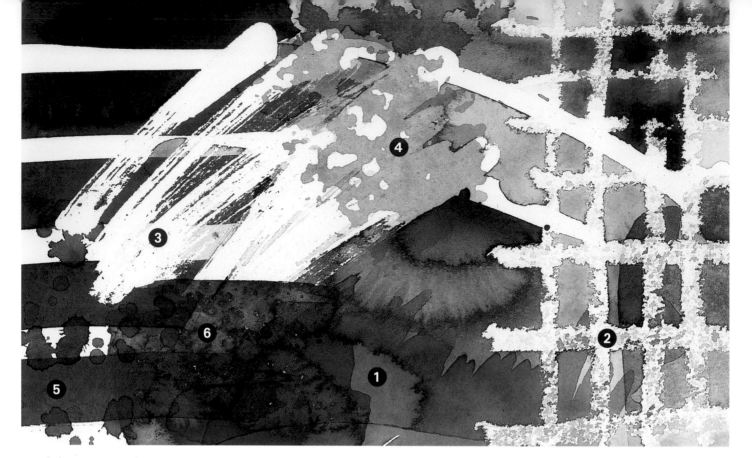

Cold-pressed papers: Cartiere Aquarello

140 lb (280gsm)

Machine mold-made/2 natural deckles/2 torn edges

Sheet size 22 x 30 in (560 x 760mm)

The Magnani paper mill is situated in the Italian town of Pescia, northwest of Florence. The town's paper mills have been famous since the 13th century. At the beginning of the 19th century, Pescia had over 100 mills. Today the Magnani mill manufactures paper for industry. It also produces a range of printmaking and drawing papers, as well as a single watercolor paper.

The paper is made from 100 percent cotton. It is sized internally, and has a neutral pH. The paper is a creamy white, and has two natural deckles and two torn edges. Each sheet carries a watermark, which is the Magnani family M surmounted by a cross. The paper has a very smooth, fine wove-textured surface. The reverse side of the paper is characterized by a pattern of delicate lines, derived from the couching felts. Both sides are workable.

The paper is thin, and must be stretched. Stretching is straightforward; adhesive tape sticks well, and the paper dries quickly and very flat. It benefits from being wetted and allowed to dry just once before work begins. This softens the sizing and allows the paint to settle into the fibers more easily.

■ **Montage of techniques: 1** Wet-on-dry
2 Wax resist **3** Masking fluid
4 Sponging **5** Spattering **6** Salt

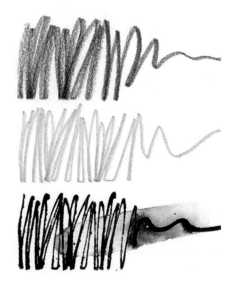

■ **Pencil/Ink** Despite the fine surface, the 3B pencil produces an open tone which shows much of the paper texture.
• The 3H needs a little more pressure but also glides smoothly; it leaves a slight indentation.
• The nib catches slightly, but always moves on without alteration of pressure. The stroke against the nib width is fluid and responsive.
• The dry ink dissolves fairly easily.

Ratings in brief

Absorbency	●●○○○
Speed of absorbency	●●●●○
Wet strength	●●○○○
Amount of size	●●●●○
Ease of correction	●●●●○
Whiteness	●○○○○
Roughness	●○○○○
Uniformity of texture	●●○○○
Cost	●●○○○
Formats available	■
Heaviest weight available	140 ——— 280
	lb gsm

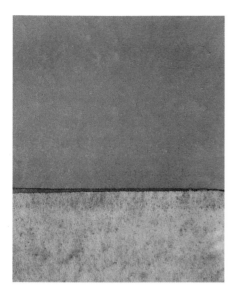

▌Flat wash/Granulated wash The paper is extremely smooth, and the brush floats effortlessly over the surface.
- Washes flow on easily, but amounts must be consistent to avoid watermarks.
- Colors seem to lighten when dry, so deep colors must be mixed strongly.
- Some areas dry marginally paler than others.
- The effects of a granulated wash are inconsistent.

▌Wet-in-wet The red paint enters the damp yellow at a steady rate, pushing the yellow pigment before it.
- The swatch dries with a hard orange watermark where the colors merged.
- Little yellow pushes back into the red.
- Mixing washes wet-in-wet without forming watermarks will be difficult, because differing pigment-to-water ratios will vary the behavior of washes on the sized surface.

▌Brushmarks/Detail The paper is suitable for fine lines and detail.
- All of the brushes give long, well-filled strokes.
- The brushmarks hold their shape, with a slight build-up of darker pigment at the edges.
- Varying amounts of paint deposited within a stroke result in both drying marks and watermarks.

▌Dry brush Dry brush works very well.
- The slight texture, allied with the paper's capacity to carry paint some distance, enables a relatively quick dry brush build-up.
- The only danger is over-wetting the brush, which could clog the strokes.

▌Masking The liquid flows on easily, and can be used to paint fine masked areas.
- The dried fluid peels away with gentle rubbing, and leaves a crisp edge.
- Tape also sticks easily and leaves a sharp edge.
- The tape pulls a little when lifted, so extra care is needed.

▌Corrections/Sgraffito A bit of moderate scrubbing with a bristle brush removes most of the paint.
- Fibers begin to lift and roll into balls after heavy scrubbing.
- Sandpaper quickly raises the fibers and flattens the paper texture.
- Scratching pulls at the paper and feels unpleasant.

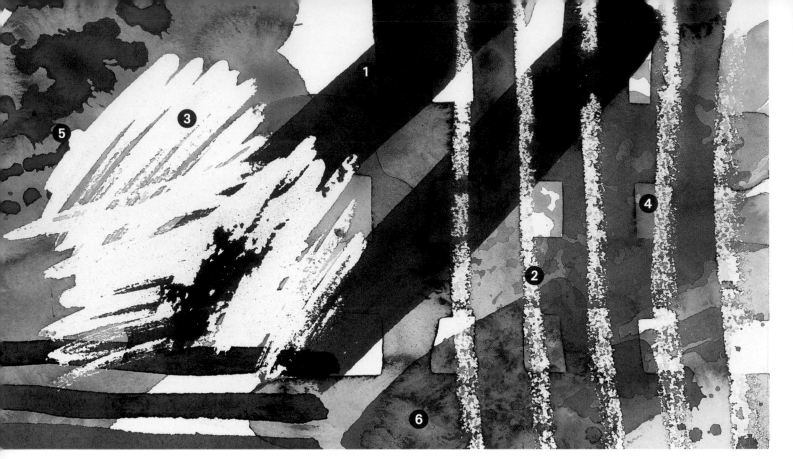

■ **Montage of techniques: 1** Wet-on-dry
2 Wax resist **3** Masking fluid
4 Sponging **5** Spattering **6** Salt

Cold-pressed papers: Hahnemuhle Aquarelle
90 lb (200gsm)
Machine-mold made/2 natural deckles/2 torn edges
Sheet size 22 x 30 in (560 x 760mm)

This paper is made at the Buttenpapierfabrik Hahnemuhle, in the village of Dassel, not far from Hannover, Germany. Their watercolor papers are machine mold-made, using 100 percent cotton, or a combination of cotton and high-alpha cellulose. They are sized internally with resin, and are acid-free, with a neutral pH. The paper carries the Hahnemuhle watermark of a rooster. Both sides are usable, although the front has a slightly less regular texture. The paper has two deckle edges and two torn edges.

Because this paper is lightweight, it needs stretching to avoid problems resulting from cockling. Adhesive tape sticks well, and the paper stretches easily. Washes take better if the paper is wetted and allowed to dry once before painting begins. The lack of surface sizing makes the paper quite absorbent, but although colored washes settle into the surface, they remain bright. Although the texture is not pronounced, the paper is suitable for textural techniques, such as wax resist and salt.

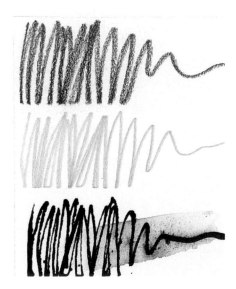

■ **Pencil/Ink** A 3B pencil, applied with only slight pressure, feels smooth and leaves a dark but grainy, textured line.
• A 3H pencil needs moderate pressure but leaves no evident indentation.
• The nib glides easily in all directions.
• Dried ink dissolves little when rewet, and leaves a light-toned wash.

Ratings in brief

Absorbency	●●○○
Speed of absorbency	●●○○
Wet strength	●●○○
Amount of size	●●●○
Ease of correction	●●●○
Whiteness	●●○○
Roughness	●○○○
Uniformity of texture	●●○○
Cost	●●○○
Formats available	■
Heaviest weight available	90 lb — 200 gsm

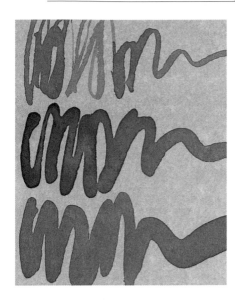

Flat wash/Granulated wash Washes glide on without friction.
• The paint brushes out easily, and settles into the paper with no evidence of puddling.
• The wash dries flat with a uniform density and no pinpricks of unpainted paper.
• The effects of granulation are very consistent. The overall effect is subtle.

Wet-in-wet The red paint creeps into the damp yellow rectangle, mixing gradually at first.
• When the red eventually stops, it strengthens from the central brushmarks and dries with a hard, orange watermark.
• To avoid such hard edges, wet paint must be added before the base layer becomes overly dry.

Brushmarks/Detail The no. 2, no. 6, and ¼ in brushes all feel smooth and responsive, and produce long strokes.
• A uniform amount of paint is delivered along their length.
• The marks hold their shape, but dry with a slightly broken, granular edge.

Dry brush The minimal texture and slight degree of absorbency seem to suit the dry-brush technique.
• Strokes from a damp bristle brush are long, well defined, and fast.
• Errors can be difficult to wipe away because of the paper's minimal ability to absorb, so avoid overfilling the brush.

Masking The liquid brushes on easily, and the paper is suitable for detailed work.
• There is no bleeding of paint beneath the masked areas, and the fluid removes without pulling the paper.
• Tape is just as successful, but tugs the surface, especially if rubbed down too hard.

Corrections/Sgraffito Quite a lot of paint can be removed with strong scrubbing.
• There is no raising of paper fiber or deterioration of the surface.
• Medium-grit sandpaper cuts through the surface easily and feels controlled. The paper is left very smooth.
• A sharp blade is equally controllable but raises the fiber in places; use this tool with care.

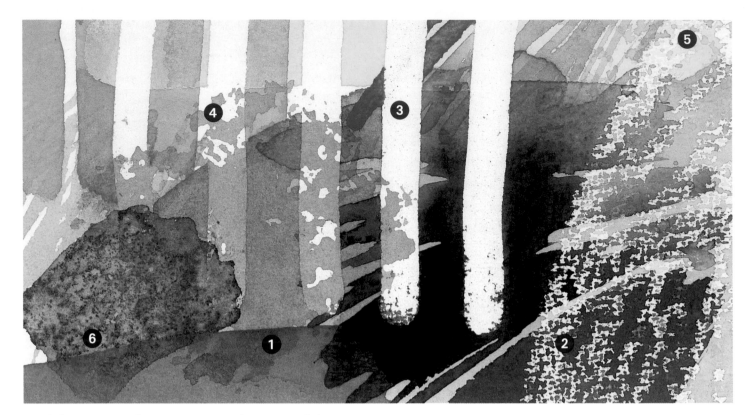

Cold-pressed papers: Schut Ambiance

250 lb (525gsm)

Machine mold-made/2 deckles/2 cut edges

Sheet size 22 x 30 in (560 x 760mm)

The Papierfabriek Schut, situated in Heelsum in The Netherlands, has been making paper for artists since 1618. Its present wide range of art papers includes a line of watercolor papers, each of which has its own texture. This particular paper, like many of the Schut papers, has a somewhat mechanical appearance, that can be disconcerting at first. The Ambiance paper is made from 100 percent cotton linters. It is gelatin-sized and acid-free. The paper has two deckle edges and two cut edges, and is bright white, with a distinctive regular texture. The reverse side of the paper has a more matte appearance, and the texture is slightly less pronounced.

The paper is available in three weights: 95 lb (200gsm), 165 lb (355gsm), and 250 lb (525gsm). All benefit from being stretched, and are more receptive if wetted and dried once before use. Stretching presents no problem for this paper, and colors dry bright. Washes layer on with little color pickup, and the paper takes most textural effects quite well. Despite its seemingly pronounced surface texture, the paper is very smooth to work upon.

Montage of techniques: 1 Wet-on-dry **2** Wax resist **3** Masking fluid **4** Sponging **5** Spattering **6** Salt

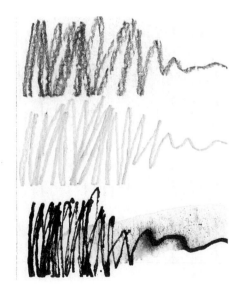

Pencil/Ink Minimum pressure on a 3B pencil creates a dark tone that shows up the texture.
• The 3H feels smooth, but needs a fair amount of pressure to make a faint mark, and leaves quite a deep impression.
• A nib catches on the side-to-side stroke and feels uncomfortable; when pulled against the nib width, it feels smoother.
• Water brushed over the ink fails to soften it more than marginally.

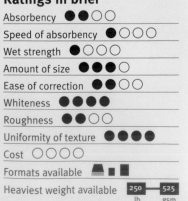

Ratings in brief

Absorbency	●●○○
Speed of absorbency	●○○○
Wet strength	●○○○
Amount of size	●●●○
Ease of correction	●●○○
Whiteness	●●●●
Roughness	●●○○
Uniformity of texture	●●●●
Cost	○○○○
Formats available	◣ ▪ ■
Heaviest weight available	250 lb — 525 gsm

Flat wash/Granulated wash There is no drag from the paper texture.
- A brushload goes a long way.
- The mechanical texture is most evident when the paper is wet.
- The paint dries uniformly and shows a subtle speckled effect.
- Granulation works better than usual on a Cold-pressed paper; the pronounced texture allows the pigments to settle and separate.

Wet-in-wet The red paint steadily pushes the damp but drier yellow almost to its limits.
- Little yellow mixes back into the red.
- The swatch dries with a faint orange watermark at the point of the color transition.

Brushmarks/Detail Brushmarks hold their shape well, drying with a crisp edge and no sideways bleed.
- All three brushes spread the paint a fair distance and feel light and responsive.
- There is no discernible pull from the texture. Fine work and detail should present no problem.

Dry brush Dry brush works extremely well.
- The heavy sizing and the economy of paint enables the painting of long, fluid, dry brushstrokes.
- Each bristle stands out.

Masking The liquid paints easily onto the hard surface.
- Despite the paper's texture, it leaves a crisp image when overpainted.
- The fluid can be rubbed from the paper with no pulling.
- Tape behaves well in all respects.

Corrections/Sgraffito The removal of dry paint by rewetting and scrubbing is reasonably successful. The sizing seems to hold the paint at the surface.
- The paper is relatively tough and does not deteriorate.
- Sanding reaches virgin paper quickly and leaves a pleasant, open texture.
- Scratching easily reveals the paper, making very fine lines possible.

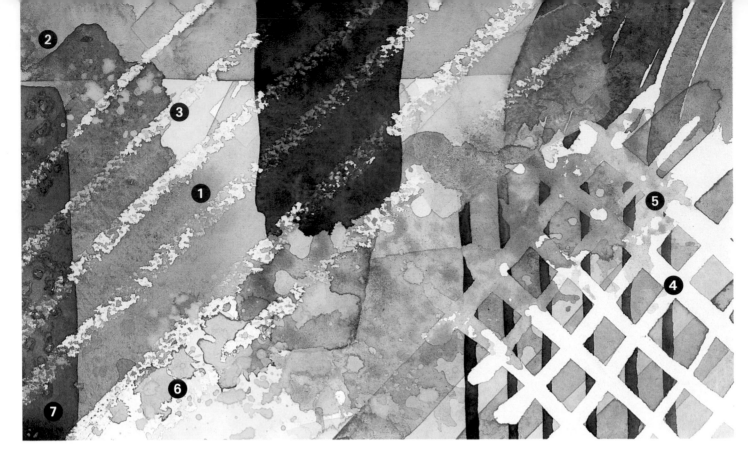

Cold-pressed papers: Two Rivers (Passion Handmade)

200 lb (410gsm)

Handmade/4 natural deckles

Sheet size 22 x 30 in (560 x 760mm)

This paper is handmade at the small Two Rivers mill in Wachet, Somerset, England. In the US, it is sold under the name "Passion Handmade." The paper is produced from a mixture of cotton and flax. It is internally sized using a synthetic wax, and is surface-sized with gelatin. It is buffered with calcium carbonate to help prevent environmental contamination. The paper is a soft creamy white. It is identified by its four deckle edges, and the watermark TR HANDMADE, followed by the year of manufacture. The paper is also made in 140 lb (300gsm) and 300 lb (640gsm) weights, and is available in five tints: cream, sand, oatmeal, green, and gray. The mill will supply a rougher-surfaced paper upon request.

The paper benefits from being stretched, and the manufacturer recommends a prolonged soaking. Adhesive tape sticks to the surface easily and does not lift. Colored washes take better if the paper is wetted once and allowed to dry before painting. The paper is suitable for all traditional watercolor techniques, and washes sit brightly on the surface.

Ratings in brief

Absorbency	●●○○○
Speed of absorbency	●●○○○
Wet strength	●●●○○
Amount of size	●●●○○
Ease of correction	●●●●○
Whiteness	●●○○○
Roughness	●●○○○
Uniformity of texture	●●○○○
Cost	●●●○○
Formats available	■
Heaviest weight available	300 lb — 640 gsm

■ **Pencil/Ink** The stroke is smooth and responsive, and the graphite mark reveals the paper texture.
• A 3B pencil needs a little pressure to make a dark line.
• A 3H pencil feels stiffer, needs more pressure, and leaves a slight indentation.
• The nib is overall slightly resistant, even against its width.
• Rewet ink softens enough to create a light-toned wash.

Flat wash/Granulated wash The paper feels soft and smooth beneath the brush.
• Washes sit for a while on the surface before being absorbed.
• The effects of granulation are fairly unexciting, due to the subtle paper surface.

Wet-in-wet The red paint is reluctant to move into the damp yellow rectangle.
• For the paint to flow and mix well, the paper needs to be extremely wet.
• Where the paint does blend, the color transition is smooth and subtle.

Brushmarks/Detail All three brushes feel smooth and responsive.
• The paint brushes out well.
• A brushload goes a good distance.
• Brush strokes hold their shape, with no sideways bleed.
• The quality of the edge is sharp, but slightly granular.
• The edge tends to dry slightly darker than the center.

Dry brush This technique works well on this surface.
• As soon as the paint ratio is right, the strokes become long and the individual bristles stand out.
• Overall, the brush produces a long stroke.
• Delivery is fast, making it possible to build up an area of work very quickly.

Masking The fluid paints on easily, dries quickly, and comes away with gentle rubbing.
• The mark revealed is clean and sharp.
• Masking tape also works well on this surface, and leaves a sharp edge.
• The tape should be removed with care; if applied heavily, it can tear the surface.

Corrections/Sgraffito Corrections are easy; rewetting and gentle rubbing remove a substantial amount of paint.
• Sanding removes paint quickly, but raises the paper fiber.
• Scratching can create very fine lines.

More papers...

Atlantis

190 lb (400gsm)/
sheet size 48 x 60 in
(1220 x 1520mm)

Made and sold by the Atlantis art store in London, England, this large sheet is mold-made from 70 percent wood pulp and 30 percent cotton fiber. The paper is gelatin tub-sized, and has a neutral pH. It works with most techniques, but corrections made by washing off dry pigment can be difficult.

Ratings in brief

Absorbency	●●○○
Speed of absorbency	●●●○
Wet strength	●●●○
Amount of size	●●○○
Ease of correction	●●○○
Whiteness	●●○○
Roughness	●●○○
Uniformity of texture	●●●○
Cost	●●○○
Formats available	■
Heaviest weight available	190 lb — 400 gsm

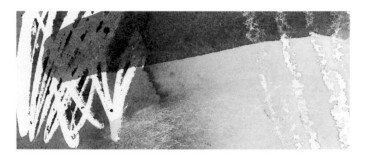

Cotman

140 lb (300gsm)/
machine mold-made/
4 cut edges/
sheet size 22 x 30 in
(560 x 760mm)/
chopmarked Cotman

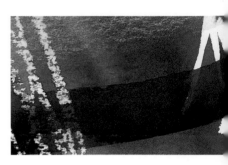

This is a relatively easy and forgiving paper to use. Colors wash on smoothly, and washes dry flat. The surface is reasonably hard and smooth, making masking and fine-line work easy. Washes sit well on top of each other, and a degree of paint removal is possible by rewetting.

Ratings in brief

Absorbency	●●○○
Speed of absorbency	●●○○
Wet strength	●●●○
Amount of size	●●○○
Ease of correction	●●○○
Whiteness	●●●○
Roughness	●●○○
Uniformity of texture	●●●●
Cost	●○○○
Formats available	▬ ■
Heaviest weight available	140 lb — 300 gsm

Canson Fontenay

140 lb (300gsm)/mold-made/2 deckles/sheet size
22 x 30 in (560 x 760mm)/watermark Fontenay

This is a relatively smooth paper with a slightly granular feel to the surface. Washes take well, as do masking and wax-resist techniques. A degree of paint can be removed by rewetting, but this technique is not entirely satisfactory. Take care when removing masking tape.

Ratings in brief

Absorbency	●●○○
Speed of absorbency	●●○○
Wet strength	●●○○
Amount of size	●●●○
Ease of correction	●●○○
Whiteness	●●○○
Roughness	●●○○
Uniformity of texture	●●●●
Cost	●○○○
Formats available	▬ ■ ■
Heaviest weight available	140 lb — 300 gsm

Ratings in brief

Absorbency	●●○○
Speed of absorbency	●●○○
Wet strength	●●●○
Amount of size	●●●○
Ease of correction	●●●○
Whiteness	●●●●
Roughness	●●○○
Uniformity of texture	●●●●
Cost	●○○○
Formats available	▬ ■ ■
Heaviest weight available	170 lb — 350 gsm

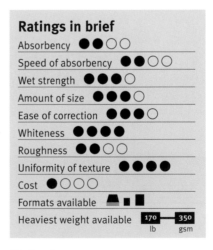

Fabriano 5

140 lb (300gsm)/mold-made/2 cut edges/2 deckles/
Sheet size 20 x 28 in (500 x 700mm)/
watermark FA5 Fabriano 50% Cotton

Made from a mixture of 50 percent cotton and selected cellulose, the paper is acid-free. It is recommended by Fabriano for use with several different materials, including felt-tip markers and charcoal, making it an ideal paper for experimental, mixed-media work. The surface is relatively hard, with a slight canvas-like texture.

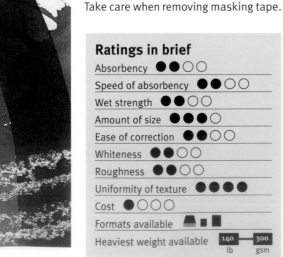

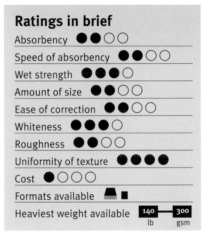

Ratings in brief

Absorbency	●●●○
Speed of absorbency	●●○○
Wet strength	●●●○
Amount of size	●●○○
Ease of correction	●●○○
Whiteness	●●○○
Roughness	●●○○
Uniformity of texture	●●●●
Cost	●●○○
Formats available	■
Heaviest weight available	140 lb — 300 gsm

Two Rivers de Nimes

140 lb (300gsm)/handmade/4 deckles/
sheet size 17 x 22 in (440 x 560mm)/
watermark T R Handmade

Another quality handmade paper from the Two Rivers mill in Somerset, England, this one has a laid surface. It comes in a creamy, off-white color, and is available in five other tones. Both sides are usable, with the reverse side being a little smoother. The paper is made from cotton rag, with a bit of denim rag added for extra strength. The sheets are internally and surface-sized with gelatin. The paper accepts all watercolor techniques.

Fabriano Esportazione

140 lb (300gsm)/handmade/4 deckles/
sheet size 22 x 30 in (560 x 760mm)/
watermark C M Fabriano

This paper is lovely to use; colors seem to sit on its surface, and show great depth. The surface is hard, helping with masking and fine line work. Colors blend well, and the paper's absorbency helps washes soak in and dry without leaving watermarks. It is hard to remove paint by rewetting, making corrections difficult.

Ratings in brief

Absorbency	●●●○
Speed of absorbency	●●●◐
Wet strength	●●●●
Amount of size	●●○○
Ease of correction	●○○○
Whiteness	●●○○
Roughness	●●○○
Uniformity of texture	●●●○
Cost	●●●●
Formats available	■
Heaviest weight available	282 lb — 600 gsm

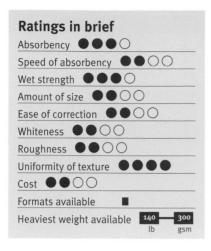

Ratings in brief

Absorbency	●●●○
Speed of absorbency	●●○○
Wet strength	●●○○
Amount of size	●●○○
Ease of correction	●●○○
Whiteness	●●○○
Roughness	●●○○
Uniformity of texture	●●●●
Cost	●●○○
Formats available	■
Heaviest weight available	115 lb — 250 gsm

Schoellershammer 4R

115 lb (250gsm)/machine mold-made/4 cut edges/
sheet size 20 x 28 in (510 x 720mm)

A very smooth paper made from high-alpha cellulose and cotton; in many respects it feels like a Hot-pressed paper. Washes brush on very easily, but if too much paint is washed on, watermarks and drying marks can form. Colors look very bright, and corrections can be made relatively easily by washing off paint. Take care not to tear the surface when removing masking tape.

Twinrocker

200 lb (425gsm)/handmade/4 deckles/sheet size 22 x 30 in (560 x 760mm)/Twinrocker logo embossed

This paper has a very slight texture on the front side, with the reverse side being slightly smoother; both are usable. The paper is very bright, and washes take well to its surface. The hard surface sizing keeps colors bright, and allows for a fair degree of manipulation. Masking tape tends to tear the surface, so care should be taken when using it. Otherwise, the paper accepts all techniques with ease.

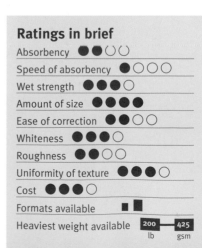

Ratings in brief

Absorbency	●●○○
Speed of absorbency	●○○○
Wet strength	●●●○
Amount of size	●●●●
Ease of correction	●●○○
Whiteness	●●●○
Roughness	●●○○
Uniformity of texture	●●●○
Cost	●●●○
Formats available	■ ■
Heaviest weight available	200 lb — 425 gsm

Working with Cold-pressed paper

Cold-pressed papers are generally considered easy papers to work on, taking in most techniques very well. Take care not to overwork the painting, however, as paintings overworked on this type of paper tend to look dull and lackluster.

Materials

- Bockingford
 Cold-pressed surface
 200 lb (425gsm) paper
- B pencil
- Masking fluid
- Large, round wash
 brush
- Natural sponge
- Medium-grit
 sandpaper
- 1 in (25mm) flat bristle
 brush
- No. 4 round sable
 brush
- No. 6 round sable
 brush

Masking Working over a light B pencil drawing, the base texture for the roughly painted wall of crumbling plasterwork is laid. Using a bristle brush, masking fluid is loosely scrubbed onto the surface over those areas intended to remain as clean paper, or to be overlaid with light washes. Once dry, a round brush is used to wash on the first thin washes. When these are dry, the masking fluid is removed by gently rubbing with the finger. The resulting dry paintwork already closely resembles the weathered wall.

Sponging A natural sponge, dipped into a thin mixture of yellow ocher and Paynes gray, is then used to make quick, clean dabs to reinforce the distressed, crumbling look of the wall. The puddled paint is allowed to dry naturally. The sponge is also used to sweep paint across the pale area of wall behind the standing figure.

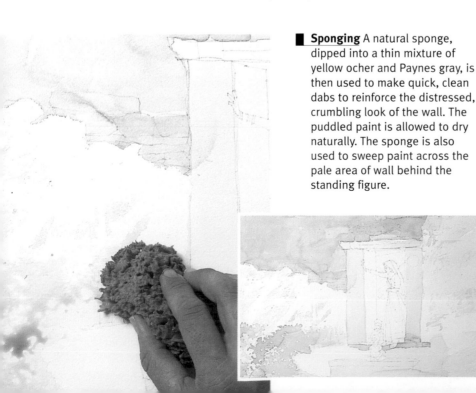

Texture The Cold-pressed texture of this paper, shown unpainted in the top lefthand half of the sheet, accepts most techniques easily. Colors stay bright, and it takes a fair degree of punishment. It is capable of accepting very loose washes together with finer, more precise techniques. The Cold-pressed texture neither dominates nor impedes the work.

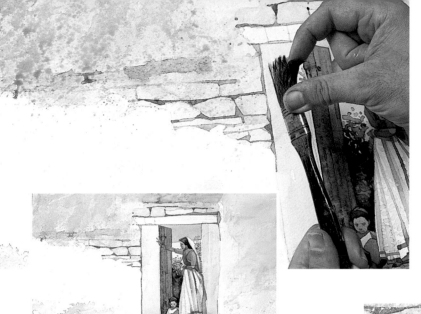

■ Spattering After spending some time working on the figures and the detail around the doorway with a mixture of wet-in-wet and wet-on-dry work, attention returns to the distressed wall. The stonework above the plasterwork on the left of the painting is softened, and further interest is added by spattering the area with a thin paint using a 1 in (25mm) house-painting brush. Once the paint is dry, the process can be repeated to build up the texture in layers.

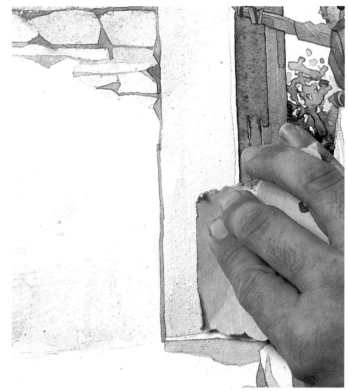

■ Sgraffito and pencil Once completely dry, the wall is worked on further using a medium-grit sandpaper to remove some of the paper surface, so that more texture can be added. The sandpaper is also pulled down the huge pieces of stone that make up the doorframe, thereby adding striation marks.

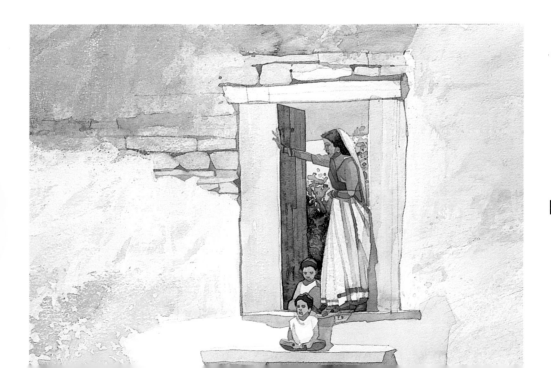

Ian Sidaway Udaipur
■ Cold-pressed paper

The painting is brought to its conclusion by working into the paintwork using a soft pencil to redefine some of the edges of the stonework, bringing the distressed wall into sharper focus.

assorted papers

Hot-pressed papers are smooth, and invariably heavy-sized. The paper can repel washes, making them puddle and leaving pronounced watermarks. This is known as cissing, and can be alleviated by adding a wetting agent to the water such as oxgall, which will reduce the surface tension of the wash and make it flow more easily.

There are many unusual, more exotic papers to paint upon with watercolors; some may display eccentricities, however, by not accepting washes easily, or by being overly absorbent. Fortunately, there are ways to deal with these sorts of problems; remedies include sizing the paper yourself, or adapting and tailoring the technique and your working practices to suit the paper's unique characteristics. Often, the best way to discover how to work with non-traditional papers is to buy a sheet of the type of paper that you desire to work with, and experiment with it.

Characteristics:
Hot-pressed paper has a smooth, polished, or glazed surface. The textures of unusual papers will vary according to the type of cellulose used.

Pat Dews AWS, NWS
Snow Ridge
Rice paper

The artist has painted the rice paper using watercolor, cut and torn it, and then stuck it down in layers to create a highly textured, multi-colored surface.

Gerald J. Fritzler Gondolas
Hot-pressed paper

The smoothness of the paper lends fluidity and smoothness to the wet-in-wet washes. The water- and drying marks seen in the deep blue/green color beneath the boats emphasize the gentle movement of the water.

Ou Li Zhuang Lobsters
Rice paper

The absorbency of this unsized rice paper is countered with fast, considered brushwork. Any hesitation would have led to too much paint being sucked from the brush, and the resulting shapes would have lacked form.

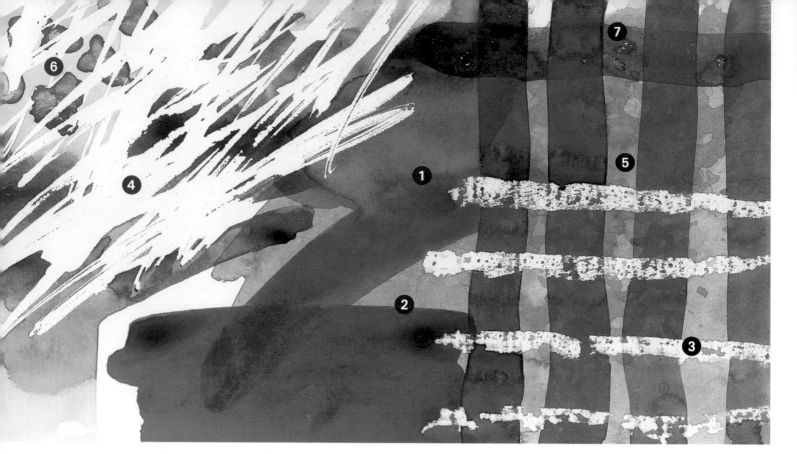

Hot-pressed papers: Schoellershammer 4G

120 lb (250gsm)

Machine mold-made/4 cut edges

Sheet size 20 x 28 in (510 x 720mm)

This paper comes from the artist's watercolor range made at the Schoellershammer mill in Duren, Germany. Manufactured using cotton and high alpha cellulose pulp, the paper is machine mold-made, and is internally sized. It comes in a bright, off-white color. The paper is identifiable by a number and letter code which indicates the paper's type of surface, and by the Schoellershammer circular stamp appearing in one corner. The paper is very smooth, with no discernible texture. There is virtually no difference between the front and back, and both surfaces are equally usable. The paper is cut smoothly on all four sides.

The paper must be stretched before it can be used. It curls alarmingly when wet, so you will need to prepare well and work quickly. If stretched correctly, the paper dries flat after each application of wash and suffers no additional cockling.

The paper's smooth, hard surface absorbs paint slowly. The sizing forces the paint into puddles, resulting in drying marks. When this happens, the painting gives the impression of fighting back. The solution is either to integrate the marks as part of the work, or to remove excess paint from the puddles with a dry brush, which will help to minimize the effect. Although the paper is not among the easiest to use for broad washes, it is highly suitable for all types of line work.

Ratings in brief

Absorbency	●●●○
Speed of absorbency	●●○○
Wet strength	●●○○
Amount of size	●●●●
Ease of correction	●●○○
Whiteness	●●●○
Roughness	●○○○
Uniformity of texture	●●●●
Cost	●●○○
Formats available	■
Heaviest weight available	120 lb — 250 gsm

Montage of techniques: 1 Wet-on-wet **2** Wet-on-dry **3** Wax resist **4** Masking fluid **5** Sponging **6** Spattering **7** Salt

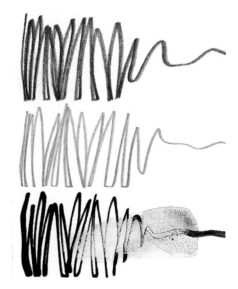

Pencil/Ink A 3B pencil needs little pressure to draw a dark line. The pencil glides over the textureless surface.
• A 3H pencil needs more pressure but leaves an equally even tone, with no indentation.
• The nib floats easily in all directions.
• The ink flows readily, and there is a risk of blobs, but very fine work is possible.
• Water almost removes the ink in some places, but leaves a pale washmark.

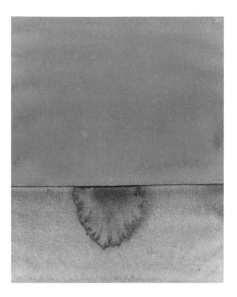

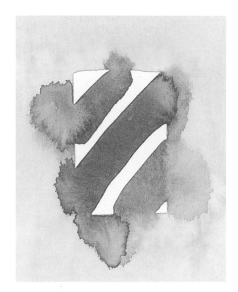

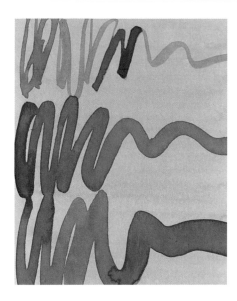

Flat wash/Granulated wash Paint flows on smoothly; the brush feels responsive.
• The paint tends to sit on the surface and puddle into the brushmarks.
• Any variation in the amount of paint results in drying marks. Achieving a flat wash with a uniform depth is near impossible.
• Granulation is almost nonexistent, because there is no texture in which the heavier pigments can accumulate.

Wet-in-wet The red paint affects the damp yellow inconsistently.
• There is some subtle mixing, but the bulk of the red puddles without moving into or merging with the yellow.
• The difference in wetness between the red and the yellow paints results in a pronounced watermark.

Brushmarks/Detail The paper is capable of a high degree of detail.
• All three brushes are responsive and smooth.
• The paint brushes out very well, and a brushload goes a long way.
• The brushmarks hold their shape, and there is no sideways bleed.
• The quality of the edge is sharp, but any excess paint puddles and dries darker in some areas.

Dry brush The paint flows from the brush to the paper very easily, so there is a risk of overfilling the brush and making a solid mark.
• When the right amount of paint is used, the stroke is long and uninterrupted, with each bristle apparent.
• The paper's lack of texture can lead to monotony, so this technique is best combined with others.

Masking Very fine work is possible.
• Thicker fluids brush on easily and leave pin-sharp edges.
• Masking tape is equally successful, giving crisp edges with no bleeding.
• The tape peels away without tearing the fibers, even when applied firmly.

Corrections/Sgraffito Rewetting and scrubbing removes a substantial amount of color.
• Overly harsh scrubbing causes the surface to deteriorate and fibers to lift.
• Sandpaper merely scratches the surface, even when applied moderately hard.
• A sharp blade makes delicate, sharp lines.

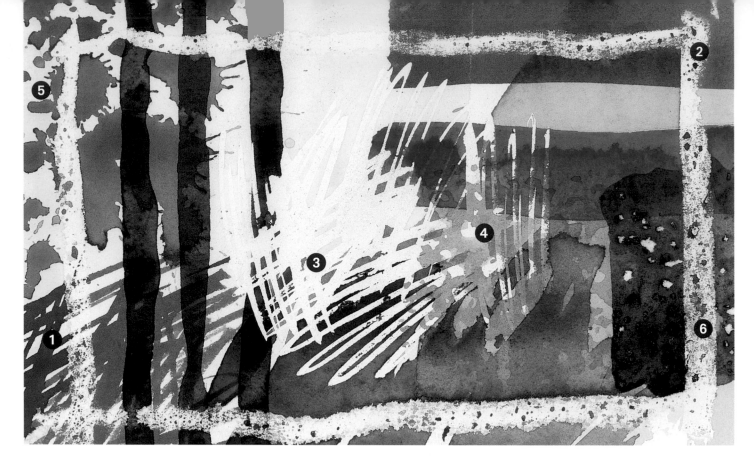

Hot-pressed papers: Saunders Waterford

140 lb (300gsm)

Cylinder mold-made/2 natural deckles/2 torn edges

Sheet size 22 x 30 in (560 x 760mm)

From the St. Cuthberts Mill in Somerset, southwest England, this paper is made from 100 percent long cotton fiber, that gives it stability when wet. The paper is cylinder mold-made, acid-free, and buffered with calcium carbonate for additional protection against environmental acidity. The paper is internally sized, and is also sized externally to increase its strength. Its smooth but slightly textured surface is creamy in color. Two edges are torn and two have natural deckles. The paper is recognizable from its watermark SAUNDERS WATERFORD and the chopmark in one corner, which reads WATERFORD SERIES. Both sides of the paper are usable, and it is supplied in three weights: 90 lb (190gsm), 140 lb (300gsm), and 260 lb (356gsm). Like the Rough and Cold-pressed papers in the Waterford line, this paper holds the Royal Watercolour Society seal of approval.

The paper benefits from being stretched, which it does with no cockling. Adhesive tape sticks well. The surface reacts better to washes if wetted and allowed to dry once before painting begins.

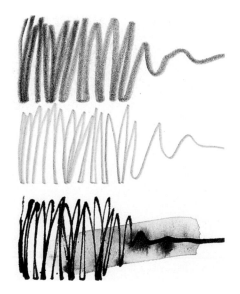

Pencil/Ink A 3B pencil produces an even dark tone, using the lightest pressure.
• The tone reveals the delicate surface texture.
• The 3H needs a greater pressure but is smooth to apply, and shows no indentation.
• A nib bites into the paper slightly, but is generally responsive.
• The ink softens quickly on rewetting, and spreads easily.

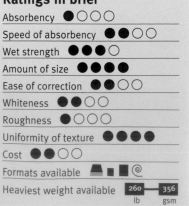

Ratings in brief

Absorbency	●○○○
Speed of absorbency	●●○○
Wet strength	●●●○
Amount of size	●●●●
Ease of correction	●●○○
Whiteness	●●○○
Roughness	●○○○
Uniformity of texture	●●●●
Cost	●●○○
Formats available	▲ ■ ▮ @
Heaviest weight available	260 — 356
	lb gsm

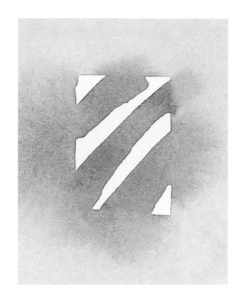

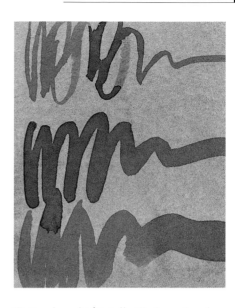

Flat wash/Granulated wash Washes brush on easily but can be difficult to control, due to the hard surface sizing.
• Using moderate amounts of paint, and brushing it out well will help.
• Flooding an area of the paper with paint causes both water- and drying marks, but less so than on many hard-surfaced papers.
• Granulation occurs, but the effect is minimal.

Wet-in-wet The red paint mixes slowly and imperceptibly with the damp yellow.
• The result is the softest transition of color in all of the tested papers.
• There is no watermark, and only a faint orange halo at the very edge of the spread.

Brushmarks/Detail All three brushes have excellent control.
• Fine work must be done on a bone-dry surface to minimize the sideways spread of paint.
• The brushmarks all hold their shape and dry with a crisp edge.

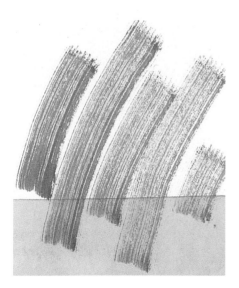

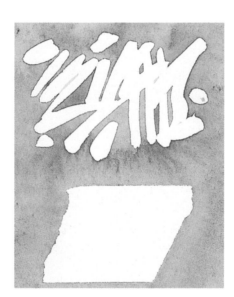

Dry brush Long clean strokes of dry brushwork are easy to execute.
• With the right consistency and amount of paint on the brush, the stroke seems to go on forever.
• Overloading the brush quickly fills the mark.

Masking The paper accepts fluid easily from both brush and pen, allowing for extremely fine work.
• Crisp effects remain when the washes are dry and the fluid is gently rubbed away.
• Masking tape gives equally good results and lifts reasonably easily.
• Care is needed to avoid a slight tug from the fibers when the tape is removed.

Corrections/Sgraffito Some paint can be removed by rewetting and scrubbing.
• This raises the fibers only slightly.
• Sanding tends to scratch the surface and pull the fibers.
• Scratching tugs the paper a little but leaves fine lines.

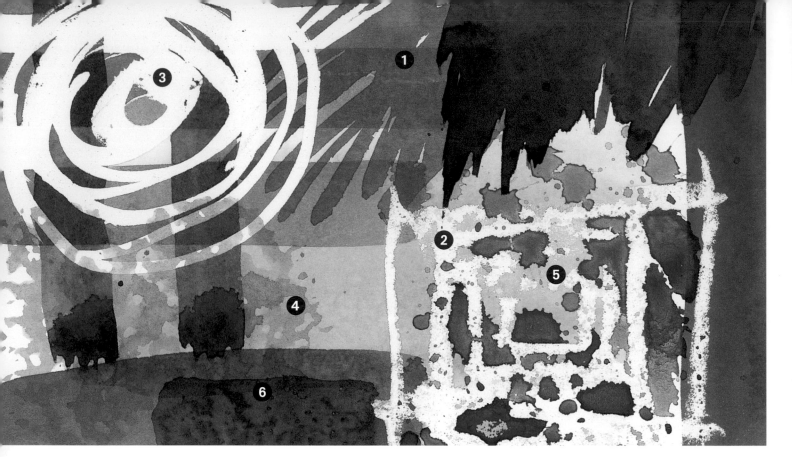

Hot-pressed papers: Arches Aquarelle

140 lb (300gsm)

Mold-made/2 natural deckles/2 torn edges

Sheet size 22 x 30 in (560 x 760mm)

Produced in France by Arjo Wiggins, this paper is machine mold-made using 100 percent cotton linters. The paper is acid-free with a neutral pH, and is treated to protect against mildew. It is internally and externally sized with gelatin. It is water-marked ARCHES FRANCE and chopmarked AQUARELLE ARCHES. The surface is a creamy off-white, and is very smooth. There is little difference between the front and back of the paper, and both surfaces are equally usable. It has two natural deckle edges and two torn edges, and is available in three weights: 90 lb (185gsm), 140 lb (300gsm), and 260 lb (356gsm).

The paper needs stretching to avoid cockling when wet. It stretches easily; adhesive strip sticks well, and the paper dries flat. The paper has a smooth, hard-size surface that causes paint to puddle before being absorbed slowly by the paper fiber. It takes all traditional watercolor techniques, but due to the absence of surface texture, the artist needs to work hard to prevent the paintwork from looking dull. This limitation is not unique to this paper alone, but is a characteristic of all Hot-pressed papers.

Montage of techniques: 1 Wet-on-dry 2 Wax resist 3 Masking fluid 4 Sponging 5 Spattering 6 Salt

Pencil/Ink With minimal pressure, a 3B pencil delivers a smooth, dark line that reveals the fine paper grain.
- A 3H pencil needs more pressure; the line is smooth but leaves a slight indentation.
- The nib floats over the paper in all directions without snagging on the fibers.
- The rewet ink dissolves quickly and spreads easily.

Ratings in brief

Absorbency	●○○○○
Speed of absorbency	●●○○
Wet strength	●●●●
Amount of size	●●○○
Ease of correction	●○○○
Whiteness	●●○○
Roughness	○○○○
Uniformity of texture	●●●●
Cost	●●●○
Formats available	▬ ■ ◎
Heaviest weight available	260 lb — 356 gsm

Flat wash/Granulated wash Paint glides on, and the brush feels responsive.
- The paint spreads well but tends to puddle over bigger areas.
- The wash dries at varying speeds, giving rise to watermarks.
- These can be reduced by brushing the paint out well, or by lifting excess paint with a dry brush.
- The effects of granulation are minimal.

Wet-in-wet The red paint spreads into the damp yellow in all directions.
- The yellow is pushed before the advancing red. Where they transmute, a faint orange watermark occurs.
- If the yellow is wetter in parts, the red will rush faster and farther into the wetter areas.
- To achieve any control with this technique, the base wash must be no more than damp.

Brushmarks/Detail The paper has an excellent capacity for detail.
- All three brushes feel responsive and deliver long, fluid strokes.
- Paint is distributed over a wide area.
- Speed of application does not seem to affect the amount deposited.
- Brushmarks hold their shape with no sideways bleed.
- The paint dries with a faintly granular but crisp edge.

Dry brush If the brush is overloaded, the paint will overwhelm the surface.
- With the right formula, however, the paper accepts the marks remarkably well.
- The smoothness enables individual bristles to create long, clean, well-separated marks that overcome the lack of texture.

Masking The fluid slides on.
- The absence of surface texture enables precise brushwork.
- When painted over, the fluid leaves crisp edges with no bleeding beneath.
- Dried fluid comes away with light rubbing. The same is true of the tape.

Corrections/Sgraffito The paint dries high on the surface with minimal penetration, due to the hard surface sizing.
- Only minimal paint can be removed by rewetting and scrubbing.
- Although the paper is quite strong, prolonged scrubbing will raise the fibers.
- Sanding removes paint smoothly.
- Scratching through the wash makes satisfactory fine lines.

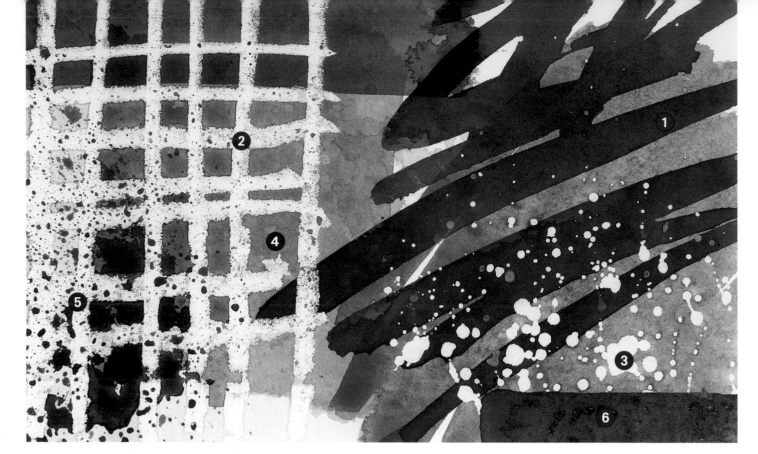

Hot-pressed papers: Fabriano 5

135 lb (350gsm)
Machine mold-made/2 deckle edges/2 torn edges
Sheet size 20 x 28 in (500 x 700mm)

This is another in the line of papers made for the watercolor artist by the Italian Fabriano paper mill. The Fabriano 5 paper is mold-made from 50 percent cotton fiber and 50 percent high-quality cellulose. It is acid-free, which protects it from aging. The bright, off-white surface is smooth, with a barely discernible, irregular pitted texture. There is little difference between the front and reverse of the paper, and both sides are usable. The paper has two deckle edges and two torn edges, and carries the watermark FA 5 FABRIANO 50% COTTON. It is also supplied in two other weights: 60 lb (160gsm), and 80 lb (210gsm).

The paper benefits from being stretched, which it does easily. Adhesive tape sticks well, and the paper stretches flat. The paper is receptive to all watercolor techniques, with the exception of the flat wash technique, which is unsuccessful on all hard-surface Hot-pressed papers.

Montage of techniques: 1 Wet-on-dry
2 Wax resist 3 Masking fluid
4 Sponging 5 Spattering 6 Salt

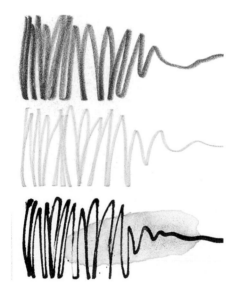

Pencil/Ink The 3B pencil floats over the surface and leaves an even, dark tone, with only a hint of the fine paper texture.
• The 3H needs slightly more pressure, but feels equally smooth and leaves no indentation.
• The nib pen feels responsive, and moves in all directions without any pulling of the paper.
• The rewet ink dissolves slowly, staining the paper and lightening the lines a bit.

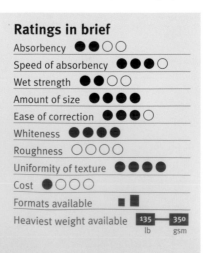

Ratings in brief

Absorbency	●●○○
Speed of absorbency	●●●○
Wet strength	●●○○
Amount of size	●●●●
Ease of correction	●●●○
Whiteness	●●●●
Roughness	○○○○
Uniformity of texture	●●●●
Cost	●○○○
Formats available	■ ■
Heaviest weight available	135 lb 350 gsm

Flat wash/Granulated wash The brush moves effortlessly across the paper.
• As the wash is formed, the paint tends to puddle within the strokes, causing watermarks when it dries. This effect is less evident than on many Hot-pressed papers.
• The granulation effect is minimal, as the texture is insufficient to separate out the pigments.

Wet-in-wet The red paint pushes into the damp yellow rectangle, mixing very little.
• The much drier yellow paint makes some attempt to push back.
• The intensity of the red paint is unaffected.
• Relatively soft watermarks mark the transition of colors when the swatch dries.

Brushmarks/Detail All three brushes feel predictably smooth and responsive on the texture-free surface.
• The paint brushes out very well, and a brushload makes a long mark.
• Fast or slow applications are delivered uniformly, but then tend to bunch and puddle within the stroke.
• The mark keeps its shape, and the edge quality is sharp.

Dry brush This technique works well.
• The paper is not quite as smooth as many Hot-pressed papers, and this affects the pickup of paint from the almost dry brush.
• The bristle markings are long and separate, and the paint goes a long way.
• The lack of absorbency prevents the paint from being pulled from the brush too quickly.

Masking The fluid paints on smoothly.
• Fine lines and detail hold up well.
• After overwashing, the paint lies slightly thicker around the masked area, resulting in a darker line of paint.
• Removal of the dry fluid leaves crisp edges with no bleeding.
• Masking tape behaves in the same way, but can tear the surface.

Corrections/Sgraffito Rewetting and scrubbing remove a lot of paint.
• The surface is tough, and there is no evidence of breakdown.
• Sanding needs some pressure to remove paint, and raises the fibers.
• The blade makes a reasonably sharp line but pulls the paper.

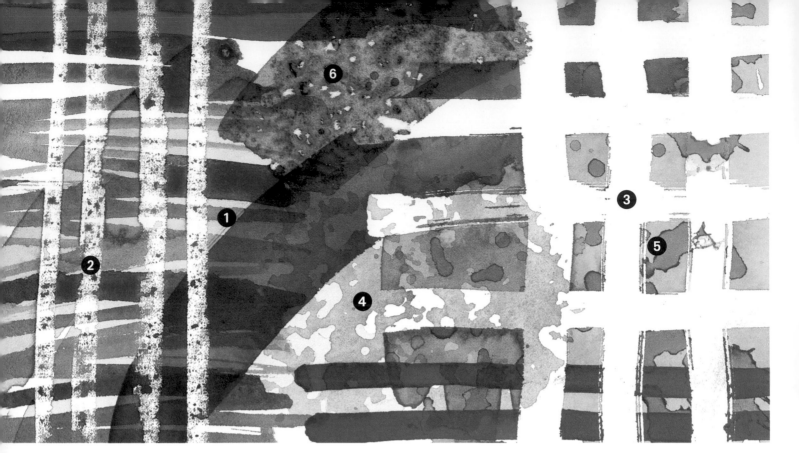

Hot-pressed papers: Lana Aquarelle

140 lb (300gsm)

Mold-made/2 deckles/2 torn edges

Sheet size 22 x 30 in (560 x 760mm)

This paper, from the Lana mill in France, is the Hot-pressed version of the Lana Rough paper featured on page 26. It is made from 100 percent cotton, and is sized both internally and externally. The surface is sized with gelatin, and it is buffered with calcium carbonate to prevent environmental contamination. The paper has a neutral pH, and carries the watermark LANAQUARELLE. It has two deckles and two torn edges, and is a bright, slightly off-white color. Both sides of the paper are usable; the reverse side has a subtle texture derived from the couching felts. It is available in three weights: 90 lb (185gsm), 140 lb (300gsm), and 300 lb (640gsm).

The paper is not as smoothly polished as some other Hot-pressed papers, and this helps washes to lie reasonably flat without too many drying marks. It benefits from stretching, which is easy to do.

Ratings in brief

Absorbency	●●○○
Speed of absorbency	●○○○
Wet strength	○○○○
Amount of size	●●●●
Ease of correction	●○○○
Whiteness	●●○○
Roughness	○○○○
Uniformity of texture	●●●●
Cost	●●○○
Formats available	▬ ▪ @
Heaviest weight available	300 lb — 640 gsm

Montage of techniques: 1 Wet-on-dry
2 Wax resist **3** Masking fluid
4 Sponging **5** Spattering **6** Salt

Pencil/Ink A 3B pencil feels smooth but needs pressure to achieve a dark tone.
• The harder 3H pencil requires greater pressure and seems to cling to the surface.
• The pen catches on the side-to-side stroke, but feels more responsive when used against the nib's width.
• The ink dissolves slowly, leaving a slight tone, without lightening the pen lines.

Flat wash/Granulated wash Hot-pressed papers are notorious for repelling washes, causing the paint to puddle and resulting in watermarks, but this paper is an exception.
• Washes brush on evenly and soak into the paper at a uniform rate.
• It is important, however, not to use excessive quantities of paint.
• Granulation occurs, but the effect is barely perceptible.

Wet-in-wet The red paint rushes into the damp rectangle, pushing the yellow before it.
• Very little yellow mixes into the red.
• The swatch dries with a conspicuous, deep orange watermark.

Brushmarks/Detail The three brushes feel responsive and controlled.
• All deliver their fill of paint over a wide area.
• The brushmarks hold their shape with no sideways bleed.
• They dry with a fairly crisp edge that has a slightly broken, granular quality.

Dry brush The smooth surface and hard sizing, along with a very slight tooth, make for the ideal mark.
• The mark does not fill in easily, nor does it look too mechanical.
• It is possible to build an intricate web of marks while retaining a certain freshness.

Masking Fluid paints on and dries easily, leaving crisp marks when removed.
• There is a very slight build-up in the denseness of the paint around the masked area, leaving a pleasant effect.
• Tape behaves similarly, but can tear the paper on lifting; use with care.

Corrections/Sgraffito Rewetting and heavy scrubbing removes only a minute amount of paint.
• Substantial and concentrated efforts cause the surface little distress.
• Sanding is successful but softens the surface, so proceed with care.
• A blade removes paint but pulls the fibers.

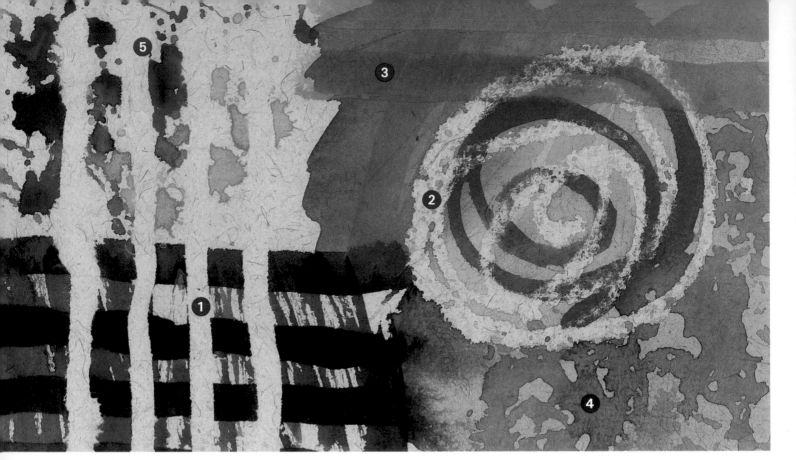

Unusual papers: Khadi Buff Gunny

90 lb (210gsm)

Handmade /4 deckle edges

Sheet size 22 x 30 in (560 x 760mm)

This paper is handmade in India from a mixture of cotton rag and reclaimed jute sacking. It has a very pleasing buff color, through which the flecks of jute fiber can be seen. Both sides of the paper can be used, with one side marginally smoother than the other. The paper is surface-sized with gelatin, and is pressed between sheets of galvanized steel to give it a Hot-pressed surface. The surface is, however, closer to a Cold-pressed surface, in that it is not very smooth.

The paper stretches easily, and the surface benefits from being wetted once and then dried before being used, which helps adhesive tape stick to the surface. When working on a toned or tinted surface, colors will tend to dry much duller than if they were painted onto a white surface, so color mixes should be as bright as possible. The paper is not very absorbent, and its heavy size makes washing paint off very easy. Because the surface is fairly delicate, it should be treated with care. The paper is also available in the same weight with a Rough surface.

Ratings in brief

Absorbency	●○○○
Speed of absorbency	●●○○
Wet strength	●●○○
Amount of size	●●●○
Ease of correction	●●●●
Whiteness	●●○○
Roughness	●○○○
Uniformity of texture	●●●●
Cost	●○○○
Formats available	■
Heaviest weight available	90 lb — 210 gsm

■ **Montage of techniques:**
1 Masking fluid 2 Wax resist
3 Wet-on-dry 4 Sponging 5 Spattering

■ **Pencil/Ink** A soft 3B pencil needs very little pressure to deliver a dark, consistent line.
• A harder 3H pencil needs a bit more pressure, and feels stiff and unpleasant.
• A steel nib catches on the paper fibers and feels awkward and unresponsive.
• Clean water just barely dissolves the dry ink.

Flat wash/Granulated wash The paper feels very smooth beneath the brush. Paint takes to the surface easily.
• The paper is not overly absorbent, thus allowing time for paint manipulation.
• Washes dry flat, but the darker jute fibers remain visible. This is in no way detrimental; the overall effect is quite pleasing.
• The effects of granulation are very subtle.

Wet-in-wet Wet-in-wet washes leave a very subtle transition from one color to the other.
• When added to the damp yellow rectangle, the red paint creeps in very slowly, mixing slightly and drying slowly.
• The swatch dries leaving a soft watermark.

Brushmarks/Detail The paper feels relatively smooth.
• All three brushes are reasonably responsive.
• Brushmarks hold their shape, with minimal sideways bleed. The marks dry with a slightly darker broken edge.

Dry brush The paper's relatively heavy sizing prevents the paint from being sucked from the brush too quickly.
• A loaded brush makes several long marks that deposit just enough paint onto the surface.

Masking Care needs to be taken with masking materials.
• Although the paper appears to be heavily surface sized, the paper surface is delicate.
• The paper fibers are easily pulled and distressed by the act of removing masking fluid by rubbing it, and by pulling off masking tape.

Corrections/Sgraffito Dry paint is easily removed by rewetting with clean water and gently scrubbing with a soft brush. The paper surface softens and deteriorates very quickly, so take care.
• Be careful with sanding as well, as the paper fibers are easily removed.
• Scratching with a sharp blade removes the surface, but the action feels unpleasant, as are the results.

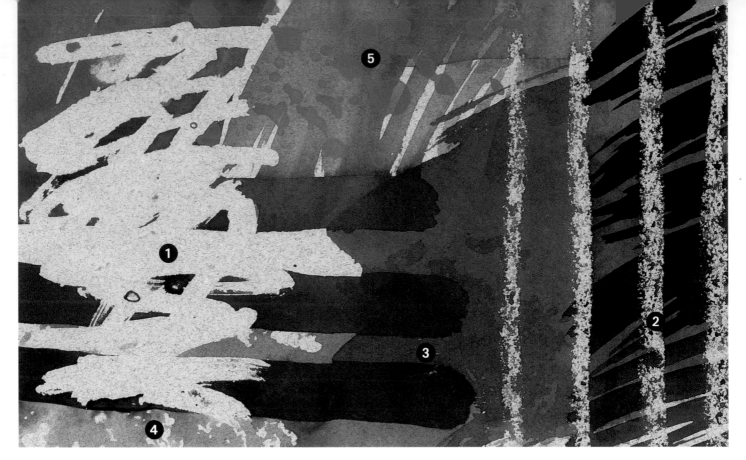

Unusual papers: Turner's Blue Wove

90 lb (200gsm)

Handmade/4 deckle edges

Sheet size 22 x 30 in (560 x 760mm)

This paper is one of several modern versions of papers originally manufactured in the late 18th century to the specific requirements of some of the greatest watercolorists in the world. The original paper was made in England, and was known as Turner's Gray. This version is made exclusively for JvO Papers, a paper company based in London, England, at the Ruscombe Paper mill. The paper is handmade from 100 percent cotton, and is surface sized with Aquapel. Its surface is relatively smooth, with a slightly granular feel to it. The paper has four discrete deckle edges, and stretches easily. Both sides are similar, and both are usable. The paper accepts all traditional watercolor techniques, and colors appear bright on its dull blue surface. Its heavy sizing facilitates corrections by making it very easy to wash paint off the surface.

■ **Montage of techniques:**
1 Masking fluid **2** Wax resist
3 Wet-on-dry **4** Sponging **5** Spattering

■ **Pencil/Ink** A soft 3B pencil requires some pressure and feels a little stiff.
• A harder 3H pencil feels smooth on the surface, but requires some pressure to leave a pale line.
• A steel-nib pen catches slightly, but not to any great degree.
• When rewet, dry ink slowly softens and spreads into a clean-water brushmark.

Ratings in brief

Absorbency	●○○○
Speed of absorbency	●●○○
Wet strength	●●○○
Amount of size	●●●●
Ease of correction	●●●●
Whiteness	○○○○
Roughness	●○○○
Uniformity of texture	●●●●
Cost	●●●○
Formats available	■
Heaviest weight available	90 lb — 200 gsm

Flat wash/Granulated wash Washes brush on smoothly and dry flat, with very little puddling of paint.
• The paper benefits from being wetted at least once and then dried before being worked on.
• Given the dull blue color of the paper, colors look surprisingly bright.
• Granulation effects are minimal, as they are disguised by the paper color.

Wet-in-wet Colors blend well and dry with an intensity and depth that would be difficult to achieve on a white surface.
• When applied to the yellow rectangle, the red paint spreads very fast initially, but slows quickly and moves little.

Brushmarks/Detail Brushmarks dry leaving a crisp, sharp edge.
• All three of the brushes feel responsive and smooth.
• The paper is capable of handling a high degree of detail.
• Brushmarks hold their shape, with no sideways creep.

Dry brush Dry brush works extremely well on this paper.
• The paper seems to possess just the right degree of sizing, coupled with a texture that makes building areas of dry brush work a simple and quick affair.
• A brush loaded with the right amount of paint delivers a series of long, well-defined strokes.

Masking Masking fluid paints on easily, making it possible to produce some fine work.
• With gentle rubbing, masking fluid is removed easily.
• Masking tape also works well, protecting masked areas from unwanted paint, and allowing no bleed.
• The tape can be removed easily, but some care should be taken because it can pull and raise paper fibers.

Corrections/Sgraffito When rewet, dry paint can easily be removed by gentle scrubbing or blotting with absorbent paper towel.
• Paint softens to such an extent that it is possible to remove almost all of it and return to the original paper color.
• Sandpaper removes both paint and paper very easily, but raises the paper fibers and destroys the surface.

More Hot-pressed papers...

Schut Vivace

115 lb (250gsm)/machine mold-made/2 cut edges/ 2 torn edges/sheet size 22 x 30 in (560 x 760mm)

This very smooth paper is good for both fine work and line work. Washes take well, and dry washes can be removed when rewet. Care needs to be taken when removing masking tape. Both sides are usable, with one side marginally smoother than the other.

Ratings in brief

Absorbency	●●○○
Speed of absorbency	●●○○
Wet strength	●●●○
Amount of size	●●●○
Ease of correction	●●●○
Whiteness	●○○○
Roughness	●○○○
Uniformity of texture	●●●●
Cost	○○○○
Formats available	◣ ▪ ■
Heaviest weight available	115 lb — 250 gsm

Whatman

135 lb (290gsm)/mold-made/4 deckles/sheet size 22 x 30 in (560 x 760mm)/ watermark Whatman

Also available in a 92 lb (185gsm) weight, this paper is made in the UK. Washes dry bright on the smooth surface, and a reasonable degree of correction is possible by rewetting and washing off color. Take care when removing masking tape.

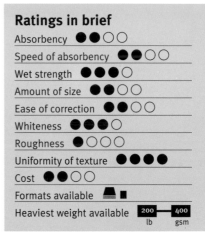

Ratings in brief

Absorbency	●●○○
Speed of absorbency	●●○○
Wet strength	●●●○
Amount of size	●●○○
Ease of correction	●●○○
Whiteness	●●●○
Roughness	●○○○
Uniformity of texture	●●●●
Cost	●●○○
Formats available	◣ ▪
Heaviest weight available	200 lb — 400 gsm

Ratings in brief

Absorbency	●●●○
Speed of absorbency	●●○○
Wet strength	●●●○
Amount of size	●●○○
Ease of correction	●●○○
Whiteness	●○○○
Roughness	●○○○
Uniformity of texture	●●●●
Cost	●○○○
Formats available	■
Heaviest weight available	300 lb — 640 gsm

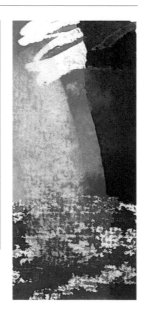

Khadi

100 lb (210gsm)/ handmade/4 deckles/ sheet size 22 x 30 in (560 x 760mm)

Made in India, this is the "smooth" version of the well-known Rough Khadi paper. The paper accepts all traditional watercolor techniques well—especially washes—and is very absorbent for a Hot-pressed paper. The smooth surface is easily spoiled by pulling and tearing off masking tape; care should also be taken when removing masking fluid. Both sides of the paper can be used.

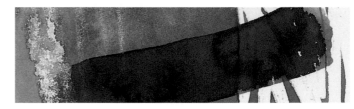

Fabriano Artistico

140 lb (300gsm)/mold-made/2 cut edges/ 2 deckles/sheet size 22 x 30 in (560 x 760mm)/ watermark CM Fabriano 100-100 Cotton

This very smooth paper takes pen and other line work well. Washes brush on very smoothly, but care needs to be taken to remove excess paint so as to avoid watermarks. The paper is usable on both front and back, and is also available in 95 lb (200gsm) and 281 lb (600gsm) weights.

Ratings in brief

Absorbency	●●○○
Speed of absorbency	●●○○
Wet strength	●●○○
Amount of size	●●●○
Ease of correction	●○○○
Whiteness	●●●○
Roughness	●○○○
Uniformity of texture	●●●●
Cost	●●○○
Formats available	◣ ▪ ■
Heaviest weight available	281 lb — 600 gsm

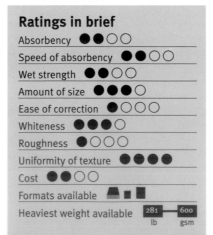

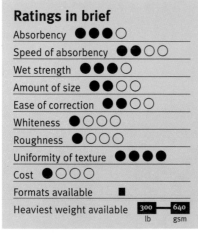

Ratings in brief

Absorbency	●●○○
Speed of absorbency	●●○○
Wet strength	●●●○
Amount of size	●●○○
Ease of correction	●○○○
Whiteness	●●●○
Roughness	●○○○
Uniformity of texture	●●●●
Cost	●○○○
Formats available	◣■▪▪
Heaviest weight available	127 lb / 350 gsm

Fabriano 5

121 lb (300gsm)/mold-made/2 cut edges/2 deckles/
sheet size 20 x 28 in (500 x 700mm)/
watermark FA Fabriano 5

Both sides of this paper are very smooth, and both can be used. The paper is particularly suited to pencil and pen work, and to all other types of work involving fine detail. Washing off paint when it is dry is only marginally effective, and care must be taken when using and removing masking tape. Masking fluid brushes on particularly well.

Twinrocker

200 lb (425gsm)/handmade/4 deckles/
sheet size 22 x 30 in (560 x 760mm)/
Twinrocker logo embossed

The only fault with this paper is that the surface is prone to tearing when masking tape is removed. Colors wash off reasonably well when rewet, making corrections possible. Pencil and pen take to the paper well, making it a good surface for any work involving line drawing. Both sides of the paper are usable, with the reverse side having a slightly irregular, more open texture.

Ratings in brief

Absorbency	●●○○
Speed of absorbency	●●○○
Wet strength	●●●○
Amount of size	●●●○
Ease of correction	●●○○
Whiteness	●●●○
Roughness	●○○○
Uniformity of texture	●●●●
Cost	●●●○
Formats available	▪■
Heaviest weight available	200 lb / 425 gsm

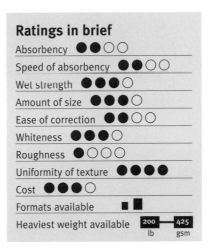

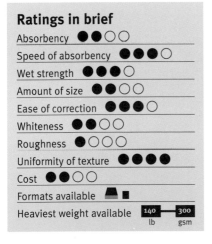

Ratings in brief

Absorbency	●●○○
Speed of absorbency	●●●●
Wet strength	●●●○
Amount of size	●●○○
Ease of correction	●●●○
Whiteness	●●○○
Roughness	●○○○
Uniformity of texture	●●●●
Cost	●●○○
Formats available	◣■
Heaviest weight available	140 lb / 300 gsm

Strathmore 500 Imperial 140

140 lb (300gsm)/machine-made/2 torn edges/
2 deckles/sheet size 22 x 30 in (560 x 760mm)/
Embossed Strathmore

Made in the USA, this paper is created from 100 percent cotton fiber. It is very smooth, and feels more substantial than its 140 lb (300gsm) weight. Both sides of the paper can be used, and it is also available in a 72 lb (154gsm) weight. The paper takes all traditional watercolor techniques in its stride, and has a reasonable capacity for corrections made by rewetting and washing off color.

Fabriano Uno

140 lb (300gsm)/
mold-made/2 torn edges/
2 deckles/sheet size
22 x 30 in (560 x 760mm)/
watermark Fabriano Uno

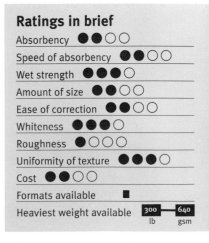

Washes brush on very smoothly and blend well, with only minimal drying watermarks. Textural effects also work well, despite the Hot-pressed, smooth surface. Most wash-off techniques are possible, including removing dry washes by rewetting, but require a degree of scrubbing to be satisfactory. The paper surface is tough, and will stand up to punishment.

Ratings in brief

Absorbency	●●○○
Speed of absorbency	●●○○
Wet strength	●●●○
Amount of size	●●○○
Ease of correction	●●○○
Whiteness	●●●○
Roughness	●○○○
Uniformity of texture	●●●○
Cost	●●○○
Formats available	■
Heaviest weight available	300 lb / 640 gsm

More unusual papers...

Two Rivers de Nimes

Cold-pressed surface/140 lb (300gsm)/
handmade/sheet size 17 x 22 in (440 x 560mm)/
watermark TR Handmade

Two Rivers de Nimes is a handmade paper with a laid, as opposed to a wove, surface. With its dark green tint, this paper has all of the same characteristics found in the white version (see page 67). The other tints available are cream, sand, oatmeal, and gray.

Ratings in brief
Absorbency	●●●○	
Speed of absorbency	●●○○	
Wet strength	●●●○	
Amount of size	●●○○	
Ease of correction	●●○○	
Whiteness	○○○○	
Roughness	●●○○	
Uniformity of texture	●●●●	
Cost	●●○○	
Formats available	■	
Heaviest weight available	140 lb	300 gsm

Ratings in brief
Absorbency	●●●●	
Speed of absorbency	●●●●	
Wet strength	●○○○	
Amount of size	●○○○	
Ease of correction	●○○○	
Whiteness	○○○○	
Roughness	●●●○	
Uniformity of texture	●○○○	
Cost	●○○○	
Formats available	■	
Heaviest weight available	65 lb	125 gsm

Lokta

Rough surface/65 lb (125gsm)/handmade/
4 deckles/sheet size 22 x 30 in (560 x 760mm)

This is one of the many Lokta papers currently available from Nepal, made from the Lokta shrub. It is a dark, rough-textured paper that has very little sizing. It is possible to stretch the paper if one does so carefully, and it dries very flat, even after several washes. The paper is very absorbent; if working wet-on-dry, it will need considerable time to dry between washes.

Khadi

Hot-pressed surface/320 lb (640gsm)/
handmade/sheet size 18 x 24 in (460 x 600mm)

Ratings in brief
Absorbency	●○○○	
Speed of absorbency	●●○○	
Wet strength	●●●●	
Amount of size	●●○○	
Ease of correction	●●○○	
Whiteness	○○○○	
Roughness	●○○○	
Uniformity of texture	●●●○	
Cost	●○○○	
Formats available	■	
Heaviest weight available	320 lb	640 gsm

This very heavy, smooth Khadi paper feels like, and resembles, a sheet of thin card. It is available in a range of colors, many too strong for traditional watercolor work. The paper is reasonably heavily sized, making corrections possible. It also takes masking tape and fluid, but will tear if either of these is removed without extreme care.

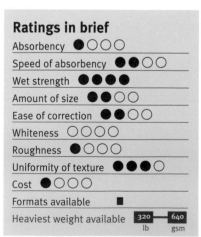

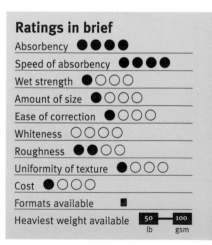

Ratings in brief
Absorbency	●●●●	
Speed of absorbency	●●●●	
Wet strength	●○○○	
Amount of size	●○○○	
Ease of correction	●○○○	
Whiteness	○○○○	
Roughness	●●○○	
Uniformity of texture	●○○○	
Cost	●○○○	
Formats available	■	
Heaviest weight available	50 lb	100 gsm

Lokta

Rough surface/50 lb (100gsm)/handmade/
4 deckles/sheet size 22 x 30 in (560 x 760mm)

This is another Lokta paper made in Nepal. When the paper is held up to the light, the coarse fibers of vegetable matter can be seen. It is made using the Japanese Nagashizuki method, where the sheet is formed in fine layers onto a silk mold. The paper contains very little size. Paint is absorbed quickly, and takes a long time to dry.

Griffen Mill Mandrill

Cold-pressed surface/38 lb (80gsm)/
handmade/sheet size 20 x 25 in (500 x 640mm)/
watermark DBGM

This paper is made from cotton linen and manila fibers. It is neutrally sized, has good wet strength, and stretches well. Washes go down smoothly, and colors dry looking rich. The mill manufactures a range of similar papers, each with the same texture, but in different colors.

Ratings in brief

Absorbency	●●○○
Speed of absorbency	●●○○
Wet strength	●●●○
Amount of size	●●○○
Ease of correction	●●●○
Whiteness	○○○○
Roughness	●○○○
Uniformity of texture	●●●●
Cost	●●●○
Formats available	■
Heaviest weight available	50 lb — 115 gsm

Banana Fiber

Rough surface/
155 lb (320gsm)/
handmade/sheet size
22 x 30 in
(560 x 760mm)

This heavy, coarse paper is made in Southern India, and is one of the many papers made using reclaimed cotton rag and vegetable fiber. In this instance, the fiber is taken from the leaves of banana trees, but paper containing fiber from sugar-cane, straw, rice husk, tea, and algae collected from local village reservoirs can also be found. The paper is well sized and not terribly absorbent; colors mix well on the surface, and corrections are possible. The high degree of size also increases the paper's wet strength. It stretches easily.

Ratings in brief

Absorbency	●○○○
Speed of absorbency	●○○○
Wet strength	●●●○
Amount of size	●●●○
Ease of correction	●●○○
Whiteness	○○○○
Roughness	●●●●
Uniformity of texture	●○○○
Cost	●●()()
Formats available	■
Heaviest weight available	155 lb — 320 gsm

Japanese Hosho

Cold-pressed surface/
36 lb (83gsm)/
Waterleaf handmade/
sheet size 24 x 35 in
(610 x 910mm)

Made in the Echizen area of Japan, this very white paper is made from Kozo fiber, and is traditionally used for woodblock printing. Watercolor takes to it very well, considering the lack of any size, with only a slight degree of spread. Colors blend softly together. If working wet-on-dry, the paper will need to be thoroughly dried between washes. The paper stays very flat, and should be stretched with care.

Ratings in brief

Absorbency	●●●●
Speed of absorbency	●●●●
Wet strength	●○○○
Amount of size	○○○○
Ease of correction	○○○○
Whiteness	●●●●
Roughness	●○○○
Uniformity of texture	●●●●
Cost	●●●○
Formats available	■
Heaviest weight available	36 lb — 83 gsm

Japanese Aku Shi

Cold-pressed surface/33 lb (67gsm)/handmade/
sheet size 25 x 38 in (640 x 970mm)

This wove paper has a delicate cream color and a surface that is roughly equivalent to an Eastern Cold-pressed paper. However, despite its sizing, this paper is far more absorbent. When working on absorbent-tone papers, make color mixes stronger to counter the inevitable deadening of color. Worked wet-into-wet, colors blend beautifully on this paper. If necessary, it can be stretched.

Ratings in brief

Absorbency	●●●○
Speed of absorbency	●●●●
Wet strength	●○○○
Amount of size	●○○○
Ease of correction	○○○○
Whiteness	○○○○
Roughness	●●○○
Uniformity of texture	●●●●
Cost	●●●○
Formats available	■
Heaviest weight available	33 lb — 67 gsm

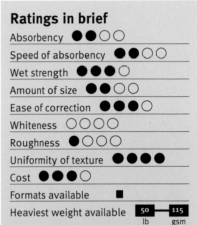
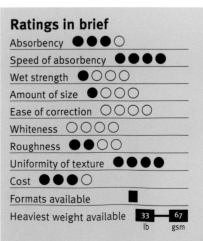

Working with Hot-pressed paper

Due to the lack of texture and the heavy sizing often found in Hot-pressed papers, washes laid upon them usually show a distinct fluidity. Although textural effects can be harder to achieve, this type of paper handles broad washes worked wet-in-wet very well.

Materials

- Fabriano Artistico Hot-pressed surface 300 lb (600gsm) paper
- B pencil
- Wide hake brush
- No. 3 round sable
- No. 6 round sable
- No. 8 round sable
- Razor blade

Wet-in-wet A large, flat hake brush is used to lay a series of washes wet-in-wet over a light pencil drawing. These initial washes give the artist a feel for the paper, and establish the overall color of the work. After these pale washes are allowed to dry, the paper is rewet, and further subtle washes of orange and blue add to the ripple effect of the sea lapping at the shore.

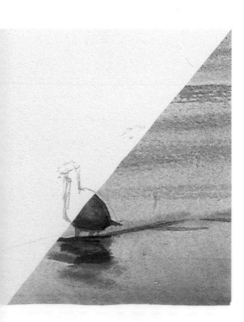

Texture This smooth paper shows off the wet, reflective surface of the beach and sea at low tide. The top left corner of the page shows the paper's unpainted surface, while the bottom right displays the effect of paint upon it. The paper is used stretched and stapled to a board, and extremely wet washes are flooded onto it to capture the "fluid" nature of the subject, using a combination of subtle color changes.

Granulation Once the initial washes are dry, the surface is rewet with clean water. Darker, more intense orange and red washes mixed with blues are brushed across the horizon, down to the lower right-hand side of the picture. The pigment combination granulates well, creating effects of water and wet sand. The board is tilted, making the paint seep in the desired direction. Before the washes dry, the reflections of the pier, waves and supports are painted in using a round sable brush.

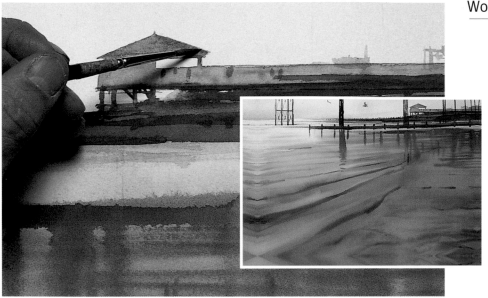

Wet-on-dry Once the atmosphere and color have been established, the painting is allowed to dry. No. 3 and no. 6 sable brushes are used to work wet-on-dry over the painting, adding the details of the building at the top right, the pier supports that run across the top of the work, and the dark, wooden breakwaters, together with the birds in the sunlit sky.

Dry brush and sgraffito By using a semi-dry brush skimmed across the paper surface, the broken-texture effect of sand seen through shallow water is achieved simply. Working onto a dry surface, further detail is added to the pier and buildings. The painting is completed by painting in the birds at the waterline and picking at the paper with a razor blade to add a sparkle of sunlight hitting the wave tops.

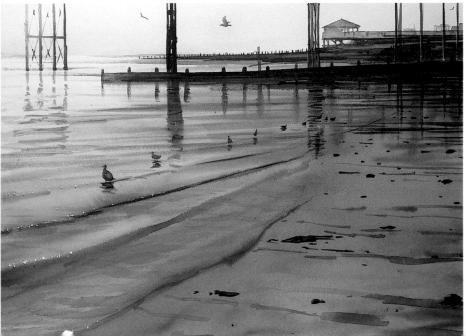

Joe Francis Dowden
Low tide
Hot-pressed paper

The finished work shows a subject and its treatment perfectly matched to a paper. The loose, yet carefully controlled washes worked wet-in-wet, layer upon layer, were ideal for capturing the elusive beauty of sunlight on the sand and sea.

resource directory

PAPER SUPPLIERS

Watercolor papers are available for sale at most fine art supply stores. Check the Yellow Pages for the location nearest you. Otherwise, you can order by mail or on-line from any of the following mail-order suppliers:

Art Supply Warehouse (ASW Express)
5325 Departure Drive
Raleigh, NC 27616-1835
Toll Free: 1-800-995-6778
Fax (919) 878-5075
http://www.aswexpress.com

Asel Art Supply
2701 Cedar Springs
Dallas, TX 75201
Toll Free 1-888-ASELART
Fax (214) 871-0007
http://www.aselart.com

Atlantis European Ltd.
7-9 Plumbers Row
London E1 1EQ
England
Tel 44 171 377 8855
Fax 44 171 377 8850

Cheap Joe's Art Stuff
374 Industrial Park Drive
Boone, NC 28607
Toll Free 1-800-227-2788
Fax 1-800-257-0874
http://www.cjas.com

Daniel Smith
P.O. Box 84268
Seattle, WA 98124-5568
Toll Free 1-800-426-7923
Fax 1-800-238-4065
http://www.danielsmith.com

Dick Blick Art Materials
P.O. Box 1267
695 US Highway 150 East,
Galesburg, IL 61402-1267
Toll Free 1-800-828-4548
Fax 1-800-621-8293
http://www.dickblick.com

Falkiner Fine Papers
76 Southampton Row
London WC1B 4AR
England
Tel 44 171 831 1151
Fax 44 171 430 1248

Flax Art & Design
240 Valley Drive
Brisbane, CA 94005-1206
Toll Free 1-800-343-3529
Fax 1-800-352-9123
http://www.flaxart.com

Jerry's Artarama
P.O. Box 58638
Raleigh, NC 27658
Toll Free 1-800-827-8478
Fax (919) 873-9565
http://www.jerryscatalog.com

New York Central Art Supply
62 Third Avenue
New York, NY 10003
Toll Free 1-800-950-6111
Fax (212) 475-2513
http://www.nycentralart.com

Pearl Paint
308 Canal Street
New York, NY 10013
Toll Free 1-800-221-6845
Fax (212) 274-8290
http://www.pearlpaint.com

PAPER MANUFACTURERS AND IMPORTERS

Contact the paper manufacturers and importers listed below to find a supplier in your area.

Aku Shi
Available through
Falkiner Fine Papers
(see *paper suppliers*)

Arjo Wiggins S.A.
6 avenue Reille
Paris 75014
France
Tel 33 144 169 600
Fax 33 144 169 930
http://www.fine-papers.com

Atlantis Paper
Available through
Atlantis European Ltd.
(see *paper suppliers*)

Banana Fiber
Available through
Khadi Papers
(see listing below)

Bloxworth
Available through
Daler-Rowney
(see listing below)

Buttenpapierfabrik Hahnemuhle
Postfach 4
D-3354 Dassel
Germany
Tel 49 556 17910
Fax 49 556 179 1377
http://www.s-und-s.de

Canson Fontenay
Available through
Arjo Wiggins S.A.
(see listing above)

Cartiere Enrico Magnani
Casella Postale 116
51017 Pescia (PT)
Italy
Tel 39 0572 405486

Fax 39 0572 405523
Cartiere Miliani Fabriano
Casella Postale 82
60044 Fabriano
Italy
Tel 39 0732 7021
Fax 39 0732 702333

Cotman
Available through
Winsor & Newton
(see listing below)

Daler-Rowney
P.O. Box 10
Bracknell, Berkshire
R612 8ST England
Tel 44 01344 424621
Fax 44 01344 860 746
http://www.daler-rowney.com

Griffen Mill
Available through
Falkiner Fine Papers
(see *paper suppliers*)

Hosho
Available through
Falkiner Fine Papers
(see *paper suppliers*)

JvO Papers
15 Newell St.
London E14 7HP
England
Tel: 44 171 987 7464
Fax: 44 171 987 9307
e-mail: john@jvo-paper.demon.co.uk

Khadi Papers
Chilgrove
Chichester PO18 9HU
England
Tel 44 01243 535314
Fax 44 01243 535354

Lana Groupe
BP 191, 92305 Levallois-Perret Cedex,
France
Tel 33 139 332 481
Fax 33 139 332 480

Moulin de Larroque
F-2411150
Couze, France
Tel 33 553 610175
Fax 33 553 240 359

Moulin de Pen-Mur
B.P. 28, F-56190 Muzillac, France
Tel 33 297 414 379
Fax 33 297 456 078

Papierfabriek Schut BV
Kabelijauw 2
P.O. Box 1
NL-6866 ZG Heelsum
The Netherlands
Tel 31 317 319 110
Fax 31 317 312 754

Papierfabrik Zerkall
D-52393 Hurtgenwald-Zerkall
Germany
Tel 49 2427 1244
Fax 49 2427 1079

St. Cuthberts Mill
Wells, Somerset
England BA5 1AG
Tel 44 1749 672015
Fax 44 1749 678844
http://www.inveresk.co.uk

Schoellershammer
Heinr. Aug. Scholler Sohne, GMBH &
Co. KG, Postfach 101946
D-5160, Duren
Germany
Tel 49 2421 5570
Fax 49 2421 557 110

Strathmore Artist Papers
39 Broad Street
Westfield, MA 01085
Tel (413) 572-9242
Fax (413) 572-9240
http://www.ipaper.com

Twinrocker Handmade Paper
P.O. Box 413, Brookston, IN 47923
Toll Free 1-800-757-TWIN
Fax (317) 563-TWIN
http://www.twinrocker.com

Two Rivers Paper Company
Pitt Mill, Roadwater
Watchet, Somerset
TA 230QS England
Tel 01984 641028
Fax 01984 641 028
http://www.tworiverspaper@hot-mail.com

Whatman
St. Leonards Road
Maidstone, Kent
ME16 0LS England
Tel 01622 676670
Fax 01622 677011
http://www.whatman.com

Winsor & Newton
Whitefriars Avenue
Wealdstone
Harrow, Middlesex
HA3 5RH England
Tel 44 181 427 4343
Fax 44 181 863 7177
http://www.winsornewton.com

Zecchi
Via dello Studio, 19/r
Firenze 1-50122 Italy
Tel (39 055) 21 14 70
Fax (39 055) 21 06 90
http://www.azienda.com/zecchi

index

credits

Quarto would like to thank all of the paper manufacturers, importers and suppliers who so kindly supplied watercolor art papers for use in this book. We would especially like to thank St. Cuthberts Mill and Daler-Rowney for supplying the sample papers included at the back of the book.

We would also like to thank Cyril Whitcombe for the use of his photograph of the overhauling room at St. Cuthberts Mill.